IRISH SEA PORTS
ON THE RIVER MERSEY AND RIVER DEE

IAN COLLARD

AMBERLEY

First published 2022

Amberley Publishing
The Hill, Stroud
Gloucestershire, GL5 4EP

www.amberley-books.com

Copyright © Ian Collard, 2022

The right of Ian Collard to be identified as
the Author of this work has been asserted in
accordance with the Copyrights, Designs and
Patents Act 1988.

ISBN 978 1 3981 1075 5 (print)
ISBN 978 1 3981 1076 2 (ebook)

British Library Cataloguing in Publication Data.
A catalogue record for this book is available from
the British Library.

Typesetting by SJmagic DESIGN SERVICES, India.
Printed in the UK.

Liverpool and Birkenhead

The Port of Liverpool is situated on the River Mersey, and includes Birkenhead. One of the earliest records of the river is found in a deed dated 1002, in the reign of Ethelred. This document bequeathed the district between the Mersey and the Ribble to the heir of Wilfric, Earl of Mercia. Up to the thirteenth century Liverpool was escribed as no more than a tiny fishing village, in the shadow of Chester, Burton and Parkgate on the River Dee. A natural harbour was formed by the 'Pool' and salt was the main trade passing through the port from Cheshire to Ireland. In 1207 King John granted Liverpool its first charter and the port slowly developed trade roues to Ireland. Corn, iron, wine and other goods were shipped through Liverpool in the fourteenth century but the Irish trade remained the most important source of revenue for the port.

In the Tudor period Chester was the centre of a customs district, which Liverpool was a part of. This caused friction between the two towns as Chester considered Liverpool a mere dependency and claimed the right to control its trade. In 1572 it was decided that civic authorities would be needed to assist the custom officers to collect their dues and duties. It was required to place the town seal on clearance documents of a ship before the Water Bailiff would allow it to leave. The dispute with Chester was settled in 1658 when the Surveyor General of Customs decided in favour of Liverpool.

Trade with the British Colonies increased in the seventeenth century, and some London merchants preferred to ship goods from America to Liverpool and transport them by road to the south of England. Tobacco and rum were imported through the port and the Great Fire of London in 1666 and the Dutch Wars dislocated the markets. Liverpool shipowners carried goods to Africa, slaves to the southern ports of America and sugar, rum and tobacco back to Britain. An Act of Parliament was passed entitled 'An Act for making a convenient Dock or Basin, at Liverpool, for the security of all ships trading to and from the Port of Liverpool'. The dock was opened in 1715, and it was the first enclosed commercial dock ever to be built and was the pioneer in dock construction. Thomas Steers was given the responsibility to survey the ground and provide plans for its construction, which included lock gates to retain water levels. Although it was opened in 1715, it was not completed until 1720.

Steers was born in Kent around 1672, entered the army in his teens and is reported to have been present at the Battle of the Boyne in 1690. He appears in the Army List of 7 July 1702 where he is described as a quartermaster in the 4th Regiment of Foot (the King's Own) and would have been involved in surveying and excavation work and purchasing items from contractors. Steers was assisted by William Braddock, and other contractors including Edward Litherland, William Bibby and Thomas Hurst, with Thomas Pattison providing the timber. A further Act was obtained in 1717 to regularise budgets and costs, which also allowed for a dry dock and three graving docks to be built at the entrance to the wet dock. Steers became a Freeman in 1713, and was elected to the Town Council in 1717 and a town bailiff for 1719 and 1722, becoming mayor in 1739. During his time as mayor he offered to build a number of houses for poor and destitute seamen on land owned by the Corporation. Steers died in 1750 and was buried in St Peter's Graveyard.

The dock soon proved insufficient to deal with the increased trade that was developing. South Dock, later renamed Salthouse Dock, was opened in 1753 and George's Dock was completed in 1771. Lighthouses were built and dues levied on all vessels were brought under the control of the Dock Trustees appointed by the Town Council. Commercial traffic increased dramatically during the American War of Independence and King's, Queen's, Princes' and Coburg docks were built. King's Dock was opened in 1788, Queen's Dock in 1796, Canning Dock in 1828 and Clarence Dock in 1830. Between 1811 and 1825 the dock water space was doubled and an Act was passed in 1825 to allow eight of the twenty-one members to be elected by the Dock Ratepayers, with the council continuing as trustees with veto powers. The new Customs House was completed in 1839 and Brunswick Dock was opened in 1832 for the timber trade. Waterloo Dock was opened in 1834, and Victoria and Trafalgar docks in 1836 for the coastal trade. The famous Albert Dock and warehouses were completed in 1846, and officially opened by Prince Albert. Salisbury, Collingwood, Stanley, Nelson and Bramley-Moore docks were completed in 1848.

The Corporation were facing a threat of competition from the Harrington Dock Company in Liverpool and a group led by Sir John Tobin and William Laird in Birkenhead. In 1843 the Improvement Commissioners drew up a scheme to build docks at Birkenhead, which was presented to Parliament, and the Birkenhead Dock Bill received royal assent the following year. Sir Philip Egerton, Member of Parliament for Cheshire, laid the foundation stone on 23 October 1844, the same day that Monks Ferry station was opened, which gave rail passengers a direct link to Liverpool. A lack of capital delayed the scheme for several years and the Commissioners were appointed Dock Commissioners. On 5 April 1847 the first two docks, Morpeth and Egerton, were opened at a cost of £2 million. The Harrington Dock Company was taken over by the Dock Board in 1843 at a cost of £253,000, and the Birkenhead Dock Company was acquired by Liverpool Corporation n 1855. The Great Float was opened by closing Wallasey Pool and using Egerton Dock as an entrance. It contained 110 acres of water, more than 4 miles of quays and was later divided into the East and West floats.

At the same time that the dock expansion was continuing merchants became dissatisfied and felt that the dues paid to the Corporation were being spent on the expansion of the town of Liverpool and not on the harbour or the facilities at the docks. The Freemen of Liverpool and some others were entitled to freedom from the dock dues until the passing of the Municipal Reform Act of 1835, giving them unfair advantage over other traders using the port. The Manchester Chamber of Commerce, Manchester Commercial Association and the Great Western Railway had all resented paying the dues on goods passing through the port. A Royal Commission was appointed in 1853 to investigate these complaints and it recommended that a new body be formed to take over the management of the docks. A bill was introduced in Parliament in 1857, and after a long and expensive struggle it was passed by both Houses of Parliament. The bill created a new constitution for the Mersey Docks and Harbour Board, and from 1 January 1858 it would be controlled by twenty-eight Dock Trustees. John Laird was appointed as a nominee of the government. The Board was then responsible for maintaining the port, which included that the entrance channels, river and docks be in good condition so that all vessels could be given a safe harbourage, and cargo discharged and loaded as quickly as possible. It was also expected that the authority would develop the port to keep it abreast with the ever-changing needs of world transportation. The new Board met for the first time on 5 January 1858 and Mr Charles Turner, merchant and Member of Parliament, was elected as chairman. Mr Laird objected to the appointment and proposed a motion that a Standing Committee be appointed to have charge of all property, docks and works on the Cheshire side until their completion. However, the motion was defeated.

Following the creation of the Board, the surveyors responsible for Birkenhead Docks, J. B. Hartley and his father Jesse Hartley, complained about the state of that dock system. The Morpeth and Egerton lock gates were warped and difficult to close, and some parts of the system required rebuilding. A consequence of the creation of the Board was that new railway lines were built on the docks at Birkenhead and the Board were responsible for maintaining all the lines on the dock estate. Morpeth and Alfred docks were extended and the Great Float opened in 1866. The entrance to the docks was through Alfred basin and engineers experienced problems keeping this dock free of sand and silt. New entrances were built at Alfred Dock and they were opened by HRH The Duke of Edinburgh on 21 June 1866. Most quays on the Birkenhead Dock Estate were served by an extensive system of railway lines which were connected to a large distribution depot at Morpeth Dock. The Wallasey Dock impounding station was built in 1886 to maintain levels in the dock system by means of large steam pumps. In 1878 the Foreign Animals Wharves were established at Wallasey and Woodside and came to handle an average of half a million animals a year. Cattle were shipped onwards or were slaughtered at the lairage and chilled meat was sent from the wharf. The lairage had an area of 98,000 sq yards and could handle over 6,000 cattle and 12,000 sheep at any one time. This trade continued into the 1960s. Large grain warehouses were built at the East Float in 1865 to deal with the increasing number of imports of grain from European, and later, North and South America, India and Baltic ports. The grain was initially shipped by rail but by the end of the century the milling companies converted many of the corn warehouses into facilities, which also bagged the flour, which was usually sent by rail, and later road to inland destinations. It was around this time that Telford, while standing on Bidston Hill, said that Liverpool had grown up on the wrong side of the River Mersey. He meant that at times the prevailing winds allowed Birkenhead to be used by ships that were unable to dock at Liverpool.

The Mersey is formed by the confluence of the rivers Tame and Goyt which join at Stockport, Cheshire. The river divides Lancashire and Cheshire and becomes tidal below Arrington Bridge. At its entrance at New Brighton the river runs south to north and the Crosby Channel continues out along the coast of Sefton. The training bank was constructed to protect the channel from excessive silt from the Great and Little Burbo banks, which are to the west. A revetment is on the north of the channel and protects the channel from sand silt from Taylor's Bank. The banks were constructed of limestone from North Wales quarries. The Rock Channel originated at New Brighton and was situated between the south end of the Great Burbo Bank and the North Bank, and was mainly used by smaller vessels. The river between the Rock Lighthouse and Dingle Point is called the Narrows and the sand bank south of the Pier Head is Pluckington Bank. The area between Dingle Point and Garston is Devil's Bank, which leads to the basin.

Distances from Liverpool Landing Stage:

Eastham – 5 miles
Woodside – 0.6 mile
Seacombe – 0.75 mile
New Brighton – 2.5 miles
Crosby Light – 8 miles
Formby Light – 12 miles
Bar Light Ship – 16.25 miles
Llandudno – 34 miles
Holyhead – 70 miles
Dublin – 122 miles
Belfast – 137 miles
Douglas – 70 miles

Ferries operated across the Mersey from New Brighton, Egremont, Seacombe, Woodside, Rock Ferry, New Ferry and Eastham. Shipyards and graving docks were by built to the south of Woodside and were operated by Cammell Laird and Grayson Rollo and Clover. Monks Ferry was the site of the first ferry point for passengers travelling between Birkenhead and Liverpool. The foreshore at Tranmere was used to beach and demolish vessels, including the Great Eastern, which was built at Millwall. The New Ferry service continued until 1922, Eastham until 1935 and Rock Ferry Pier and Stage was closed in 1939. Bromborough Dock was built for Lever Brothers Limited next to their factory specialising in the production of materials from vegetable fibre. The Bromborough cooling tower was completed in 1950 to provide a supply of cooling water for the Unilever factories in the area.

On 3 March 1879 water was pumped into the new Langton Dock and branch dock, and the *City of New York* sailed through the passage from Brocklebank Dock in May that year. Wallasey Dock was opened in 1877 and in 1881 the Prince and Princess of Wales opened the Langton Dock entrance and named the Alexandra Dock. Hornby Dock came into use in 1883. The Liverpool Overhead Railway, which ran between Herculaneum Dock and Alexandra Dock, was opened in 1893. It was an elevated passenger transport system that became known as 'the docker's umbrella'. In 1894 it was extended to Seaforth, Waterloo and Dingle in the south of the city. It ran for 6 miles along the dock road and gave passengers a view of the docks and vessels moored in the system. Following the end of the Second World War various surveys were carried out that found that the track and structure were badly corroded, and that it would be very expensive to repair the system. Consequently, the Liverpool Overhead Railway went into voluntary liquidation, and the line closed on 30 December 1956. Work to completely demolish the line commenced in 1957, and this was completed the following year.

The landing stages at the Pier Head were constructed around 1850, and the northern section was known as Prince's Landing Stage. In 1876 George's Stage, used by the ferries, was joined with Prince's Stage and extended. It was 2,534 feet long by 80 feet wide, and included approximately 200 pontoons. There were ten bridges connecting with the shore, and a floating roadway gave access to private and commercial vehicles. Both stages were scrapped in 1975/76, when the passenger liners finished operating from Liverpool, and a new stage for the Mersey ferries and the Isle of Man Steam Packet was constructed, opening in 1975. Riverside railway station was opened on 12 June 1895 to enable passengers from the steamers to get to their destinations more quickly and easily than having to be transported to the other major railway stations in the city. It was accessed via the Victoria and Waterloo tunnels and had two main platforms of 795 feet (242 metres) and 698 feet (213 metres), with a centre release track between them, and a 560-foot (170 metre) bay platform, all covered by a roof. The station incorporated waiting rooms and an inspector's office. It was rebuilt in 1945 following bomb damage during the Second World War. Because of weight restrictions, it was worked by LNWR Coal Tank locomotives operating from Edge Hill railway station until around 1950 when the line was strengthened, allowing large mainline locomotives to be operated. The station was closed when the Belfast Steamship vessel *Ulster Queen* hit the swing bridge at the entrance to Prince's Dock on 21 October 1949, and reopened on 27 March 1950. English Electric type 4 locomotives D211 and D212 were named *Mauretania* and *Aureol* at the station on 20 September 1960. The last train carried troops bound for Belfast on 25 February 1971, and it was demolished in the 1990s.

In 1900 the water was run out of George's Dock, and Sir Arnold Thornley and B. Hobbs were given the job of designing a headquarters building for the Mersey Docks & Harbour

Board. Work on the dock offices began in 1904 and the building was completed in 1907, at a cost of £350,000. It was built with a re-enforced frame, clad in Portland stone, and was designed in Edwardian baroque style, with a large dome on top. It was built on the site of the old dock, and required deeper than normal foundations, and over 35,000 tons of cement was used. As there were over 6,000 employees in the Royal Liver Group in 1907 the company felt that they needed larger premises and approval was given for the construction of the Royal Liver Building at the Pier Head. The foundation stone was laid on 11 May 1908, and the building was opened by Lord Sheffield on 19 July 1911. The Cunard Building, constructed between 1914 and 1917, was designed by William Edward Willink and Philip Coldwell Thicknesse. It is a mixture of Italian Renaissance Italy and Greek Revival and was built by Holland, Hannen & Cubitts with Arthur J. Davis of Mewes & Davis acting as consultant. The building was the headquarters of the Cunard Line, which in 1934 became the Cunard White Star Line.

The 1906 Act of Parliament allowed the Mersey Docks & Harbour Board to construct Gladstone and Gladstone Graving Dock. The Act proposed a half-tide dock with two entrances from the river, a lock connecting with the Hornby Dock, two branch docks, river walls extending as far as Cambridge Road in Waterloo. The Act also allowed for the construction of Vittoria Dock at Birkenhead. The initial scheme envisaged a double entrance at Gladstone but only one lock was built, but provision was made for the construction of another lock later. A graving dock was not proposed in the original plans but was later included in the project. Gladstone Dock was opened by King George V and Queen Mary on 11 July 1913. A flotilla of 100 vessels were anchored in the river and Helenus Robertson, Chairman of the Board, received a knighthood on the dockside in front of crowds of invited guests. However, the completion of the Gladstone complex was delayed because of the First World War and the Gladstone system was finally opened by King George V and Queen Mary on 19 July 1927. The royal party sailed through the Gladstone River Entrance and into Gladstone Branch Dock No. 1, and disembarked on the south side.

Shortly after midnight on 6 March 1909, in a snowstorm, fourteen navvies constructing a new entrance to Vittoria Dock at Birkenhead were overwhelmed by water and debris when a temporary coffer dam gave way. The gang were working on a 45-foot- (14-metre-) deep pit which formed the entrance to the new dock. At the time of the accident the men were clearing away timber and rubble, which was being hauled up to the dockside by a crane positioned across the excavation. The project had commenced in 1905 and was due to be the completed the following day.

The contract to build the dock in the Vittoria Wharf area had been awarded to John Scott of Darlington by the Mersey Docks & Harbour Board in 1905. The company was one of the main civil engineering contractors at the time and had previously completed an extension to the docks at Middlesbrough. It was envisaged that the new facility would accommodate the larger cargo vessels being introduced by the shipping companies at the time. A 200-foot-long coffer dam was built in 1907 with pilings rammed with mud and cement, and the water was pumped out of the new dock the following year. The high tide on the Mersey was at 23.15 and when the coffer dam gave way the workers were caught in the rush of water and the resultant debris. A crane, engine and boiler collapsed and it was reported that the men were then trapped underneath. The project had experienced many delays and over forty men were injured, some seriously. The engine driver and a boy acting as a signaller were eventually rescued. The boy was trapped between baulks of timber and later had his leg amputated. The local press reported that the disaster widowed seven women, left thirteen children fatherless and it took over a month to recover all of the bodies.

At the beginning of the First World War the Mersey Docks & Harbour Board claimed that the port was transformed at a moment's notice into one of the most powerful weapons in Britain's armoury. This was exemplified in the existence of the Gladstone Dock, which was virtually taken over by the Admiralty for the period of the war, and which not only enabled the giants of the mercantile marine to be reconstructed for aggressive purposes, but also afforded the facilities by which some of the capital ships of the British Navy were prepared for or restored to their positions in the first line of Britain's shield at much earlier dates than would otherwise be possible. The work of the Board was divided into working committees: the Works Committee, the Warehouse Committee, the Traffic Committee, the Pilotage Committee, the Trade Committee, the Docks and Quays Committee, and the Marine Committee.

The new Alfred Dock entrance at Birkenhead was opened on 21 July 1928 by the Earl of Derby, who had promoted the interests of the port for many years. Also in 1928, the Board sold a site at Clarence Dock to Liverpool Corporation where the Clarence Dock Power Station was later constructed. Electrical energy was supplied at high pressure and distributed for power and lighting purposes. Approximately 81 miles of main cable were laid across the dock estate and energy was also generated for parts of Lancashire and Cheshire. Land was purchased at Wallasey for oil storage, electrically operated bridges were built, and Bidston Dock was completed in 1933. The Bidston Dock project was part of a scheme, which included the replacement of five bascule bridges by swing bridges at Birkenhead and Stanley Dock, replacement of pumps at Langton Graving Docks and improvements in the Clarence Dock area. An agreement was made with Lever Brothers over the position of Bromborough Dock, which had been completed as a private dock. This agreement provided for the statutory right of the Board to Town Dues and a special rate on a small amount of third-party cargo shipped through the dock.

During the Second World War the whole of the dock system sustained extensive damage, particularly Huskisson and Canada docks. In 1941 the offices of the Dock Company took a direct hit in an air raid and the top floor and east block burnt out. In the same week the Brocklebank vessel *Malakand* berthed in Huskisson Dock with a cargo of explosives caught fire and exploded. The ship and the dock were severely damaged in this action. The Blitz in May 1941 saw the worst period of bombing and damage to the region. Many port facilities were destroyed and required urgent repairs to enable the port to function and continue its contribution towards the war effort. The headquarters of the Battle of the Atlantic was situated in central Liverpool where strategies were devised for defeating the serious U-boat threat to convoys passing through the western approaches. A total of ninety-one ships were sunk by bombing during the war, 1,285 convoys arrived at the port, 75 million tons of cargo and approximately 4.75 million troops passed through the port.

In 1948 the world's first port radar station was opened at Gladstone Dock for controlling the shipping traffic within a 20-mile range from the port. The arrival of new and larger steamers to Ireland and the needs of the smaller cargo vessels demanded the replacement of the half-tide arrangements with a new river entrance lock built to enable ships to leave, arrive and depart at practically any state of the tide. Waterloo River Entrance was constructed near to Prince's Dock, which was the base of services to and from Dublin and Belfast. The lock was built next to West Waterloo Dock with new machinery and paddles to sluice river silt from the fairway and lock approach. Work on the project started in 1937, but when war was declared, it was decided to reassess the priority of the scheme leading to a complete suspension early in 1942. Work recommenced in 1945 and the new lock was opened by HRH Princess Elizabeth on 29 March 1949. The total cost of the project was £1.5 million.

The growing oil traffic was catered for by two large projects that were undertaken by the Dock Board. An oil jetty was constructed at the south end of the Liverpool docks system and storage tanks were built on land at the rear of this site. The Dock Board also built two larger jetties on the Birkenhead side of the river at Tranmere, and these were completed in 1960. New berths were built and a new dock entrance was opened at Langton Dock in 1962, at a cost of £23 million. The Langton-Canada Improvement Scheme also comprised of the widening of the Canada-Brocklebank Passage and the remodelling of the area around the Canada Entrance and the Canada Basin. Canada lock had been built facing the prevailing wind and the flood tide, and had been damaged during the Second World War.

The 1970s saw the completion of the Royal Seaforth Terminals, which provided shipping operators with the most up-to-date port facilities for dealing with containers, timber and refrigerated cargos. Mr G. W. Brimyard, Managing Director of the Mersey Docks & Harbour Company, said in 1972 that the new facility at Seaforth would not be the new Port of Liverpool.

The port extended for 7 miles on the Liverpool side of the river and for 4 miles at Birkenhead. The total port area was nearly 2,500 acres in which there were more than 37 miles of quays and a greater volume of deep-sea exports were handled at Liverpool than any other British port. It was the beginning of the container revolution, which saw the end of conventional cargo handling and conventional cargo vessels. The Mersey Docks & Harbour Company invested in new sheds, quays and facilities for conventional cargo systems and these were out of date soon after they were commissioned. Vittoria Dock was completely rebuilt for the Far East services of the Blue Funnel Line and a £2 million scheme was completed for Clan Line services to India, Pakistan and South Africa.

The realisation that containerisation was revolutionising the carriage of goods by sea meant that most shipping operators needed to invest in new vessels which were purpose built for this trade. Many of the conventional ships were made redundant and sold to overseas operators for further trading and others for demolition. Relatively new vessels that had given their owners a small return on their investment were sold and many major shipping lines vanished from the maritime world. The first vessel used the new Royal Seaforth Dock in 1971 and the Timber Terminal opened two years later. The South Dock's system to the south of the Pier Head was closed in 1972, and the Royal Seaforth Grain terminal opened in 1974. A freightliner rail terminal was opened at Seaforth in 1980 and the Merseyside Development Corporation took over ownership and control of 405 acres of dock lands in Liverpool and Birkenhead. Waterloo and Sandon entrances were closed in 1983, and Hornby Dock was closed and filled in in 1992 for a new coal terminal to be constructed. The following year the Liverpool Bulk Terminal was opened by PowerGen at South 1 Gladstone Dock. In 1998 the Mersey Docks & Harbour Company acquired 70 acres of land between Rimrose/Derby and Regent Road for the Liverpool Intermodal Freeport Terminal. Alexandra Branch No. 1 Dock was filled in for scrap metal handling in 1999 and the following year Gladstone Steel terminal, which was rail connected, was opened at SW2 Gladstone Dock. Bidston Dock was closed and filled in in 2001, and work completed on building Twelve Quays River Berth at Birkenhead in 2002.

Liverpool2 Container Terminal was opened on 4 November 2016 as an extension to the Royal Seaforth Container Terminal. It was built on reclaimed land and is able to accommodate two 13,500 TEU New Panamax vessels simultaneously. The terminal received its largest single delivery unloading 5,452 TEUs from the MSC Federica in March 2020, and in December 2020 there was a delivery of 5,956 TEUs by MSC Tamara. OOCL and Maersk Line also use the Liverpool2 Terminal, and GB Railfreight operate five days a week rail services between Liverpool2 and the East Midlands.

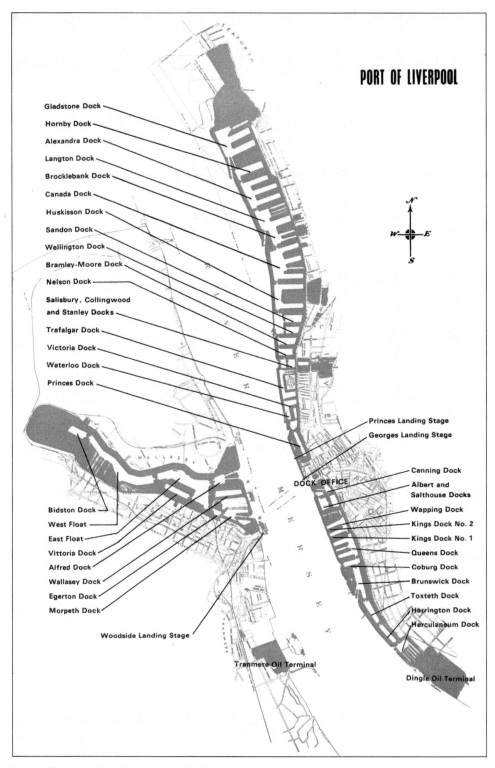

Map of Liverpool and Birkenhead docks.

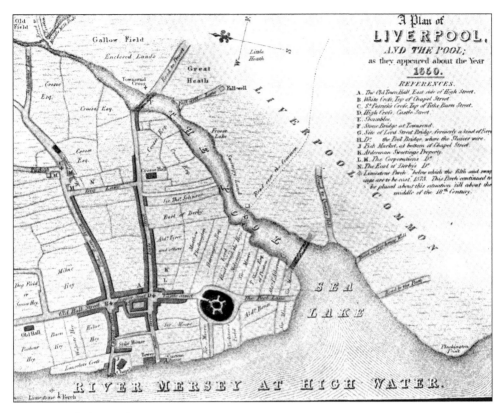

1650 map of Liverpool.

Old Dock and Custom House, 1721.

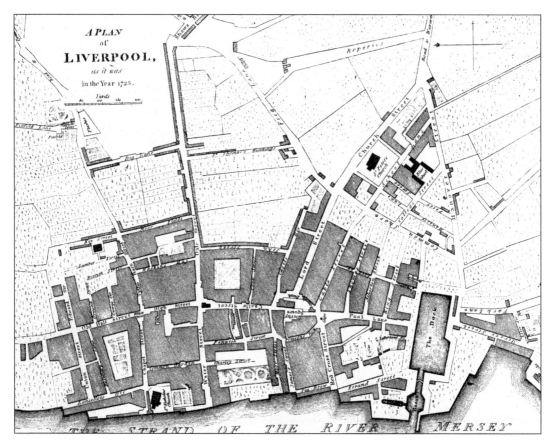

1725 plan of Liverpool.

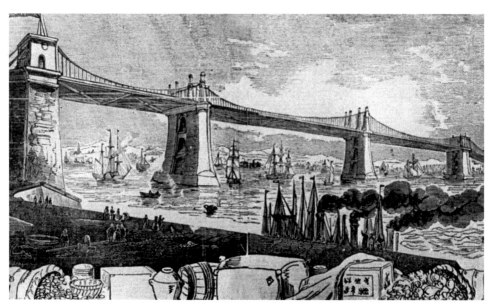

Proposed new bridge over the Mersey, 1844.

The Prince of Wales opens Langton and Alexandra Docks in 1881.

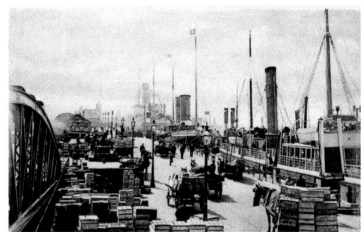

Goods are loaded onto steamers at the landing stage in Liverpool.

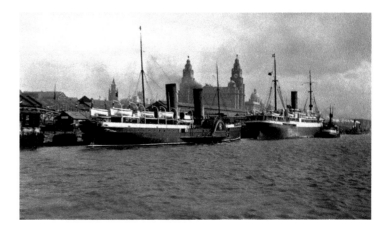

Elder Dempster's Appam (1913/7,781 grt) and the Isle of Man Steam Packet vessel *Mona's Queen* (1885/1,595 grt).

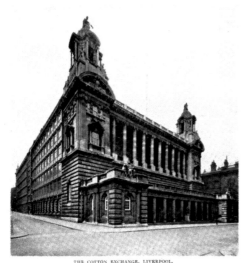

THE COTTON MARKET OF EUROPE.

	1913	1923	1924
Highest Stock of all Growths in Liverpool :	February 7th, 1,474,550.	January 5th, 877,660.	February 8th, 787,810.
			1923
Lowest Stock of all Growths in Liverpool :	October 10th, 403,940.	July 27th, 399,310.	October 5th, 269,890.

THE COTTON EXCHANGE, LIVERPOOL.

GREATEST SPOT MARKET IN THE WORLD.

The Liverpool Cotton Association Buildings comprise the finest Cotton Exchange in the world. They were erected at a pre-war cost of £367,000. There is a Cotton Bank, a Clearing House, postal, telegraphic, cable and telephone facilities.

Arbitration is provided for every phase of adjustment between buyer and seller, whether concerning interpretation of contract, class and staple, or value, or any other point between traders in which differences of opinion may exist. Liverpool arbitration is a standard throughout the cotton world. It protects every legitimate interest, and is utilised by cotton traders in every quarter of the globe.

The Liverpool Cotton Market commands resources for the selection of all grades of cotton unequalled either in England, America, or the Continent.

Buyers have the choice of every class, growth, or description of cotton and are assisted in handling and testing the exact grade they require, and the large stocks held here by merchants are of incalculable value to the spinning trade. There are Three Futures Markets, for American, Egyptian, and Empire and Miscellaneous Cotton, thus enabling traders to hedge their commitments in every growth of Cotton and minimise trading risks. These Futures Markets are the only ones of their kind in Great Britain.

The Cotton Exchange at Liverpool.

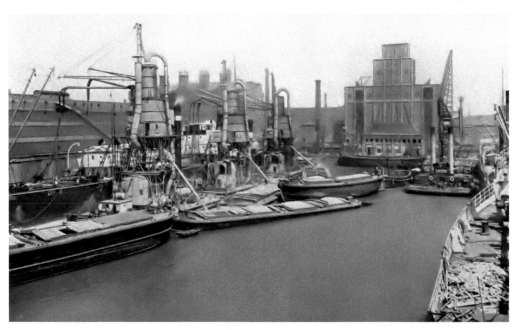

Australian wheat is discharged at Alexandra Branch No. 3 Dock, Liverpool.

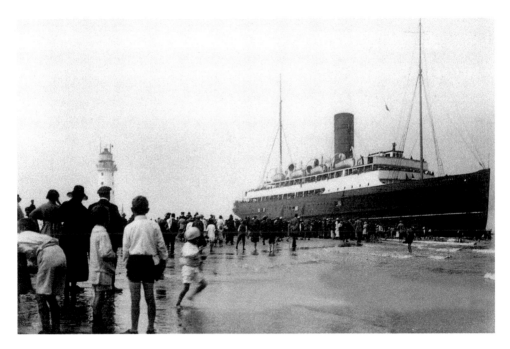

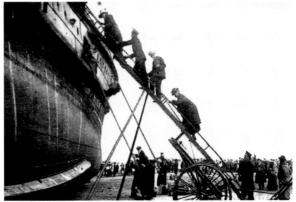

Above and right: The Isle of Man Steam Packet passenger vessel *King Orry* (1913/1,877 grt) aground at New Brighton on 10 August 1921, with 1,300 passengers on board. It was refloated later that day after some passengers were assisted to leave the vessel.

Canada Graving Dock.

Left: Vessels are overhauled in Langton Graving Dock.

Below and opposite top: The Liverpool Overhead Railway.

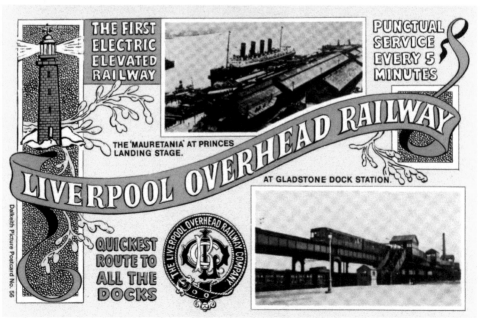

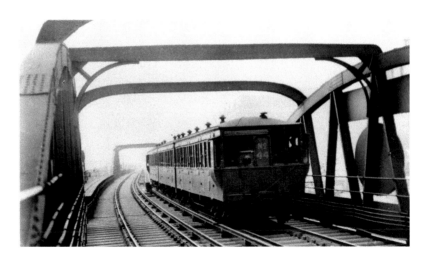

Cunard and Leyland Line vessels are discharged in Huskisson Branch Dock No. 1.

Canada Branch No. 1 Dock.

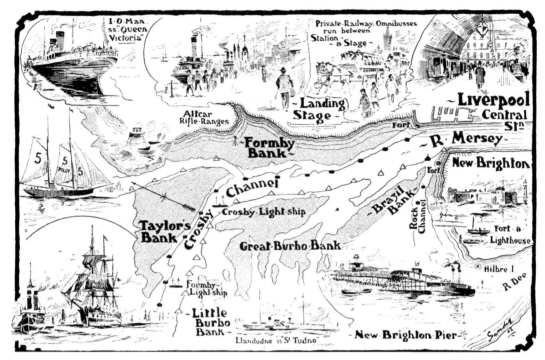

Map of Liverpool and the approach channels.

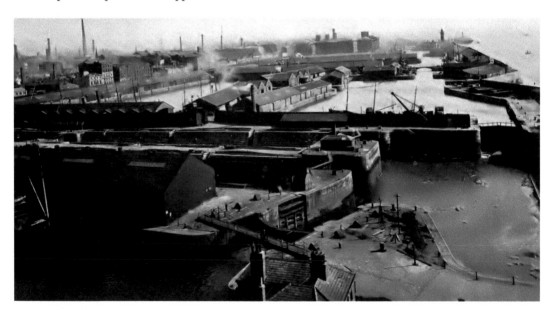

Clarence Dock looking south from the Victoria Tower.

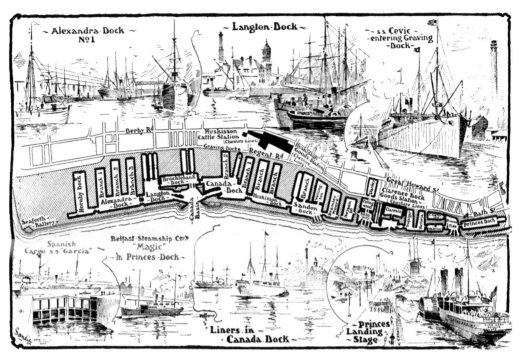

Above and below: 1904 maps of Liverpool north and south dock systems.

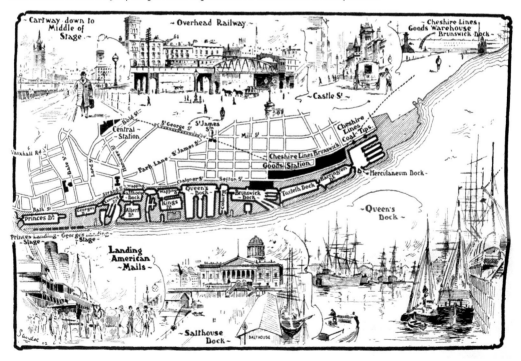

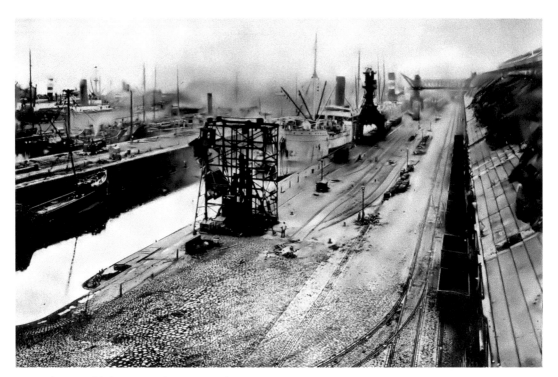

Above and below: Herculaneum Dock.

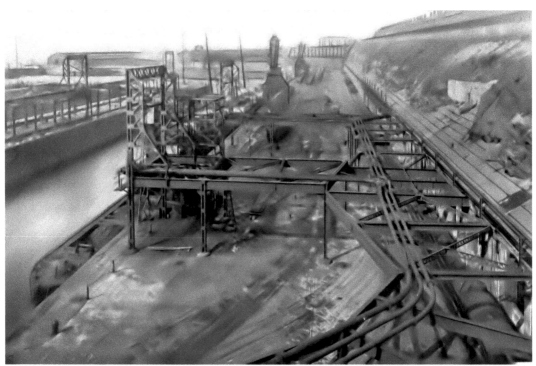

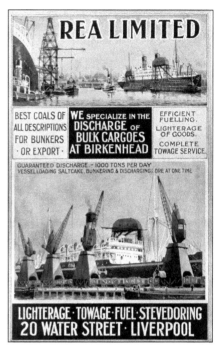

Right and above: Rea Limited discharge facilities at the East Float, Birkenhead.

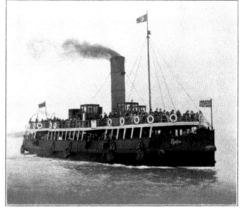

Birkenhead Corporation Ferries Woodside and Rock Ferry routes.

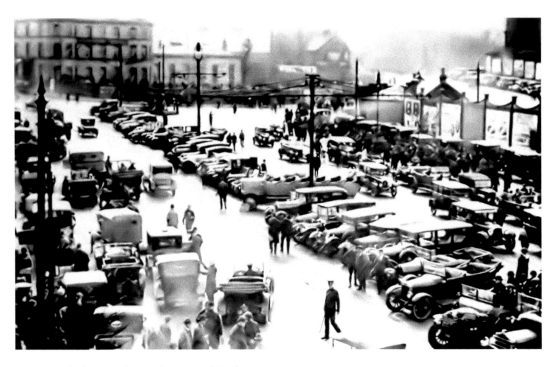

Woodside Ferry during the General Strike.

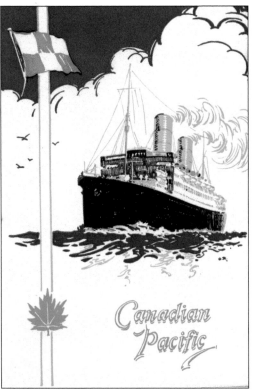

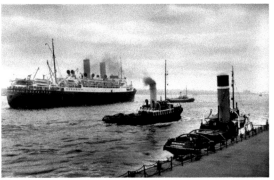

Above: Canadian Pacific's *Duchess of York* menu for 14 August 1939.

Left: The Canadian Pacific liner *Duchess of Bedford* (1928/20,123 grt) leaving Liverpool Landing Stage.

Right and below: Grayson, Rollo & Clover Docks Limited drydocks at Woodside, Birkenhead.

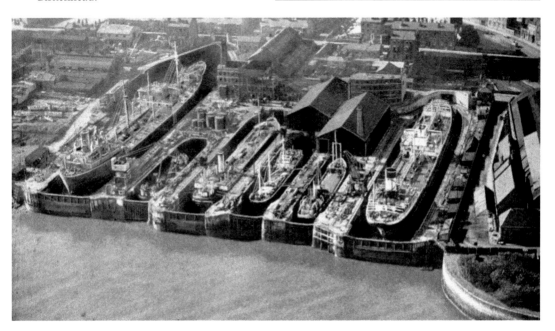

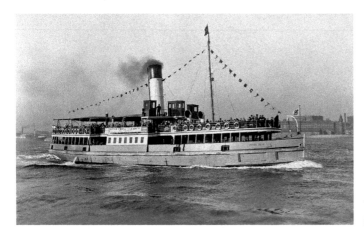

Wallasey Corporation ferry *Royal Iris*.

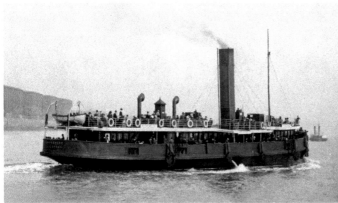

Left: Birkenhead Corporation ferry *Lancashire* (1899/469 grt). It was sold in 1930, becoming *Cathair Na Gaillimhe*, and was broken up at Cork in 1949.

Below: Gladstone Dock under construction.

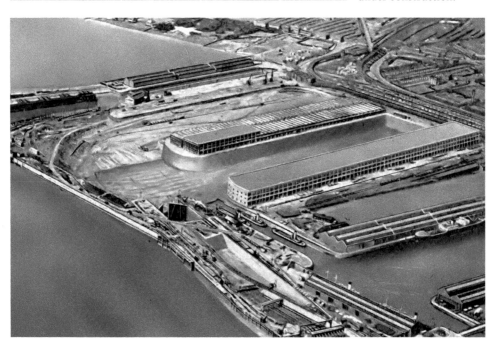

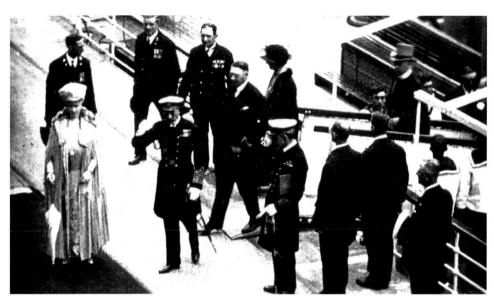

King George V and Queen Mary open Gladstone Dock on 11 July 1913. They arrived at No. 6 Bridge, Princes Parade, and proceeded to the landing stage where they embarked on the steamer *Galatea*, which passed round the merchant vessels taking part in the Marine display in the river. They then embarked on and inspected the Cunard Royal Mail steamer *Mauretania*, returning to the *Galatea*, which continued the passage along the line of vessels before entering Gladstone Dock, breaking the ribbons placed along the entrance. Their Majesties disembarked and the king inspected the guard of honour from HM Cruisers *Lancaster* and *Liverpool*. The king declared the dock open, which was followed by a fanfare of trumpets.

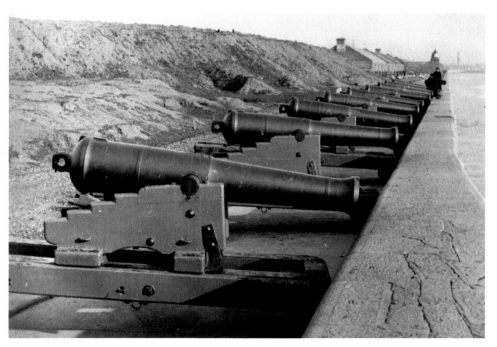

The North Wall Battery.

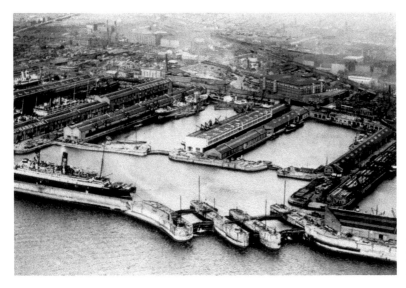

Canada, Huskisson and Sandon docks.

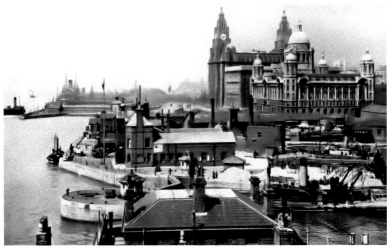

The Pier Head and Albert Dock entrance.

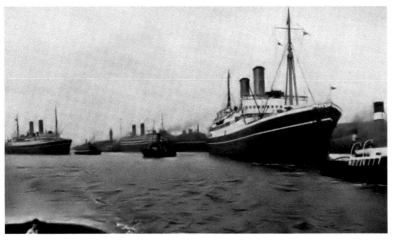

Montcalm (1921/16,418 grt) sailing for Canada, with *Montrose* (1922/16,401 grt) arriving at the landing stage, and the White Star liner *Doric* (1923/16,484 grt) at the stage.

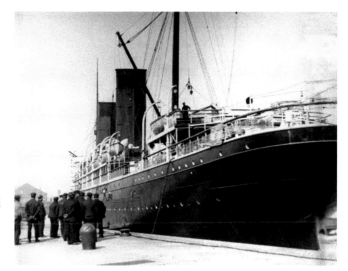

Lucania (1893/12,952 grt) in Canada Dock in 1903. It suffered a serious fire in Huskisson Dock on 14 August 1909 and was later broken up at Swansea by T. W. Ward.

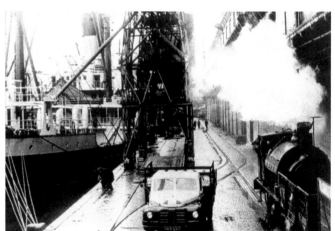

The Blue Funnel berth in Gladstone Dock.

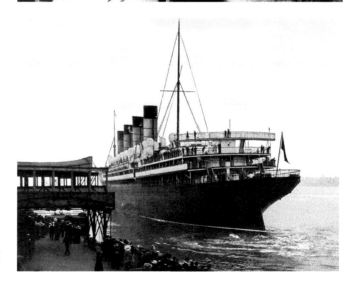

The Cunard passenger liner *Mauretania* (1907/31,938 grt) at Liverpool Landing Stage.

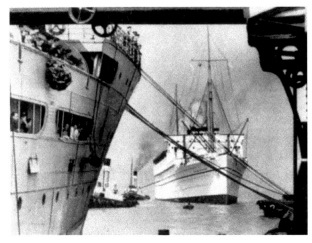

Liverpool Landing Stage.

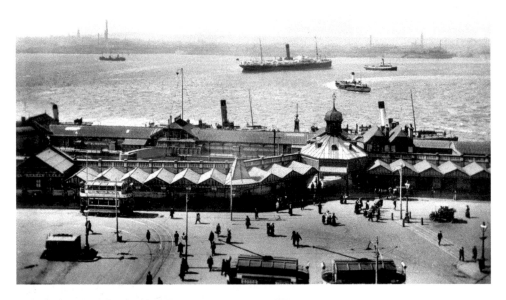

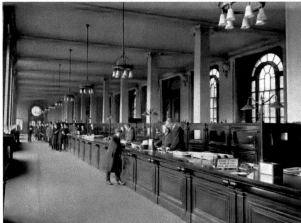

Above: Liverpool Pier Head.

Left: The Rates and Dues Department in the Port of Liverpool Building at the Pier Head.

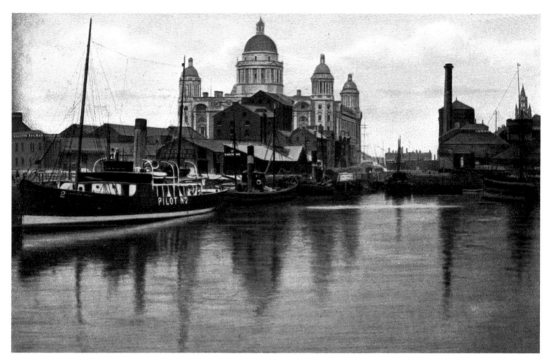

A Mersey pilot vessel prepares to sail to the Bar Lightship from Canning Dock.

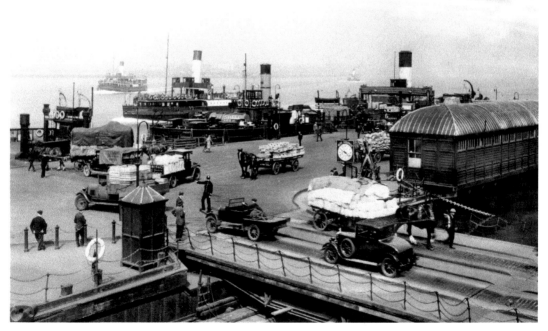

Prior to the opening of the Mersey Tunnel goods were transported across the river from Woodside and Seacombe to Liverpool Landing Stage and driven along the Floating Roadway to the Dock Road.

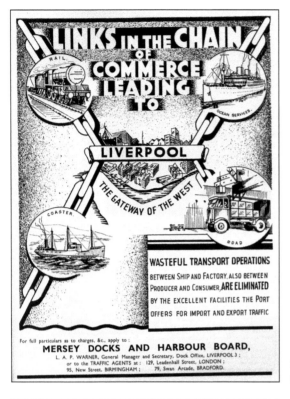

1936 Mersey Docks & Harbour Board
advertisement.

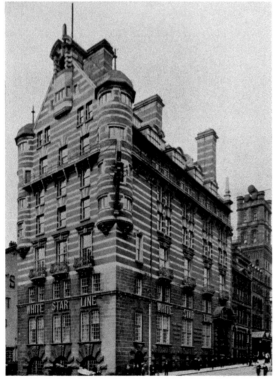

The headquarters of the White Star Line in
James Street.

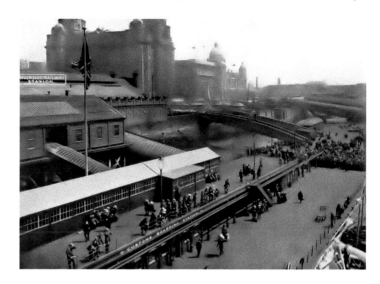

Liverpool Landing
Stage.

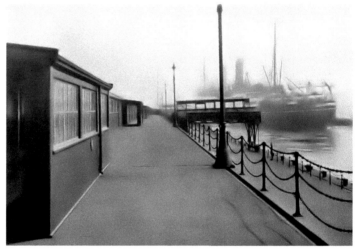

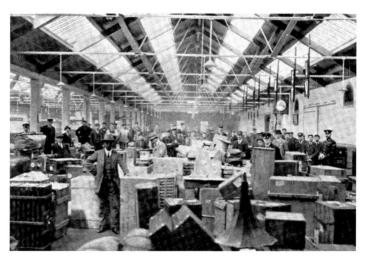

The International
Customs Examination
Hall on Princes Parade.

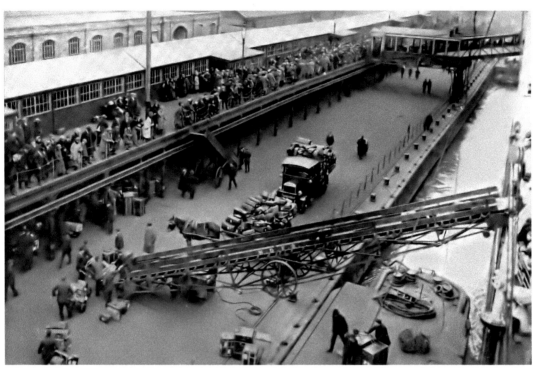

Goods are loaded and passengers embark onto a liner at the landing stage.

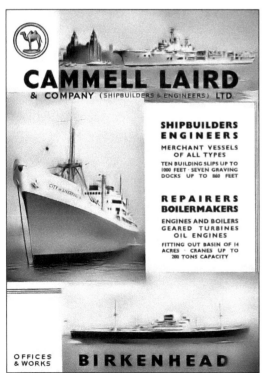

Above: 1935 Cammell Laird & Company Limited advertisement.

Left: 1950s advertisement for Cammell Laird.

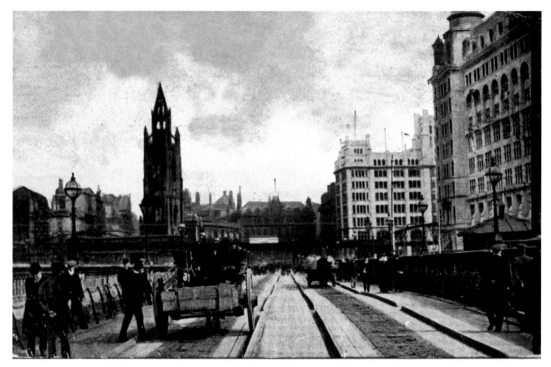

The Floating Roadway at Liverpool.

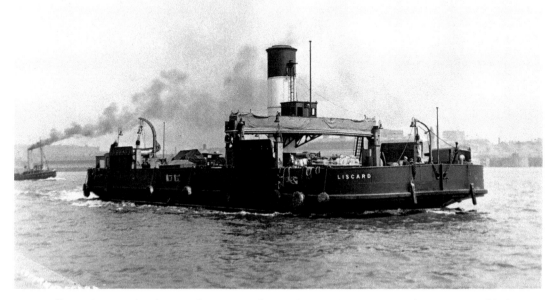

Wallasey Corporation luggage boat *Liscard* (1921/734 grt) was converted into a crane ship in 1943. It was renamed *Lisca* in 1946, *Gluckauf* in 1956 and arrived at Bremerhaven in November 1965 and was broken up.

M.V. "STAFFORDSHIRE"
CRUISE
LONDON *to* LIVERPOOL
VIA
ROTTERDAM *and* HAMBURG
RETURNING VIA
the **NORTH *of* SCOTLAND**
and the **WESTERN ISLES**
JULY 23, 1938

BIBBY LINE

Advertisement for a Staffordshire cruise from London to Liverpool via Rotterdam and Hamburg, via the north of Scotland and the Western Isles, on 23 July 1938. A special train left St Pancras station, London, at 1.50 p.m. on 23 July 1938 and passengers embarked at the Tilbury Landing Stage between 2 p.m. and 3 p.m. on the vessel that left immediately after the embarkation had been completed. A carnival dinner was served at 7.30 p.m. followed by a dance. The vessel arrived at Rotterdam at 3 a.m. and the departure was at 9 p.m. on Monday 25 July for Hamburg. On arrival at Hamburg motor launches conveyed passengers to and from the vessel and the landing stage. Staffordshire departed from Hamburg at 8 a.m. on Thursday 28 July and proceeded via the north of Scotland and down the Western Isles to Liverpool. The following year Britain was at war with Germany and in 1940 Staffordshire was requisitioned as a troopship to operate between Southampton and Rangoon. It was returned to commercial service in 1949 and survived for another ten years, when it was broken up in Japan.

Left: 1938 Mersey Docks & Harbour Board 'Port of Liverpool' advertisement.

Below: Mersey Docks & Harbour Board floating crane at work in Liverpool docks.

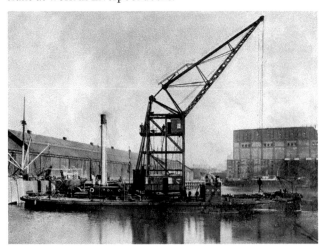

M.V. "Reina del Pacifico"—Tour round South America

PORT.	COUNTRY.	DATE.	Port to Port.	From Liverpool.
		1940.		
LIVERPOOL	Wednesday ... 10 Jan.
LA ROCHELLE-PALLICE ...	France	Friday ... 12 Jan.	605	...
FUNCHAL	Madeira	Monday ... 15 Jan.	1,152	1,757
BAHIA	Brazil	Tuesday ... 23 Jan.	3,045	4,802
RIO DE JANEIRO ...Arrive	„	Thursday ... 25 Jan.	745	5,547
„ Sail	„	Friday ... 26 Jan.
SANTOS...	„	Saturday ... 27 Jan.	208	5,755
MONTE VIDEO ...Arrive	Uruguay	Monday ... 29 Jan.	893	6,648
MONTE VIDEO ... Sail	„	Monday, p.m. 29 Jan.
by River Steamer for				
BUENOS AIRES ...Arrive	Argentina	Tuesday, a.m. 30 Jan.	122	6,770
„ Sail	„	Tuesday, a.m. 30 Jan.
MONTE VIDEO ...Arrive	Uruguay	Wednesday, a.m.31 Jan.	122	6,892
MONTE VIDEO ... Sail	„	Wednesday ... 31 Jan.
PORT STANLEY	Falkland Islds.	Saturday ... 3 Feb.	1,027	7,919
PUNTA ARENAS	Chile	Monday ... 5 Feb.	559	8,478
PUERTO MONTT	„	Thursday ... 8 Feb.	1,095	9,573
JUAN FERNANDEZ Arrive	Robinson	Monday ... 12 Feb.	811	10,384
„ Sail	Crusoe's Isld.	Tuesday ... 13 Feb.
SAN ANTONIO	Chile	Wednesday ... 14 Feb.	365	10,749
VALPARAISOArrive	„	Thursday ... 15 Feb.	42	10,791
„ Sail	„	Monday ... 19 Feb.
ANTOFAGASTA	Chile	Wednesday ... 21 Feb.	580	11,371
MEJILLONES	„	Wednesday ... 21 Feb.	60	11,431
IQUIQUE	„	Thursday ... 22 Feb.	178	11,609
ARICA	„	Thursday ... 22 Feb.	109	11,718
MOLLENDO	Peru	Friday ... 23 Feb.	132	11,850
CALLAO (for Lima)...Arrive	„	Sunday ... 25 Feb.	456	12,306
„ Sail	„	Tuesday ... 27 Feb.
BALBOA (for Panama) Arr.	Rep. Panama	Friday ... 1 Mar.	1,345	13,651
„ Sail	„	Saturday ... 2 Mar.
CRISTOBALArrive	Canal Zone	Saturday ... 2 Mar.	47	13,698
„ Sail	„	Sunday ... 3 Mar.
KINGSTONArrive	Jamaica	Monday ... 4 Mar.	560	14,258
„ Sail	„	Wednesday ... 6 Mar.
HAVANAArrive	Cuba	Friday ... 8 Mar.	750	15,008
„ Sail	„	Sunday ... 10 Mar.
NASSAU	Bahamas	Monday ... 11 Mar.	381	15,389
BERMUDA	Bermuda	Thursday ... 14 Mar.	818	16,207
VIGO (Optional) ...	Spain	Thursday ... 21 Mar.	2,698	18,905
LA ROCHELLE-PALLICE ...	France	Saturday ... 23 Mar.	464	19,369
PLYMOUTH	England	Sunday ... 24 Mar.	350	19,719
LIVERPOOL	„	Monday ... 25 Mar.	355	20,074

Total Miles on Tour : 20,074

Above left, above right and below: Advertisement for a 'Round South America' voyage by the *Reina Del Pacifico* (1931/17,702 grt), leaving Liverpool on 10 January 1940. However, *Reina Del Pacifico* was converted into a troop carrier in December 1939 and operated in Norway, West Africa, Cape Town and Suez in 1940. It returned to service with the Pacific Steam Navigation Company in 1948, and was broken up ten years later.

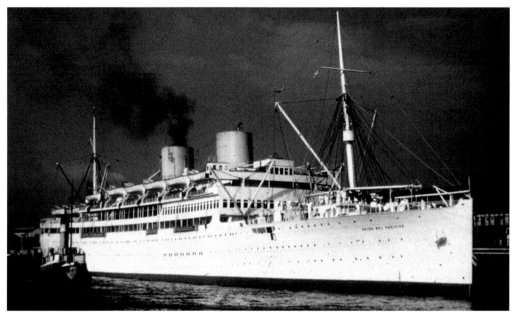

Ulster Herdsman (1923/1,526 grt) at the Dublin berths in Prince's Dock. It was built as *Copeland*, became *North Down* in 1946, *Drover* and *Ulster Herdsman* in 1954 and was broken up in 1963.

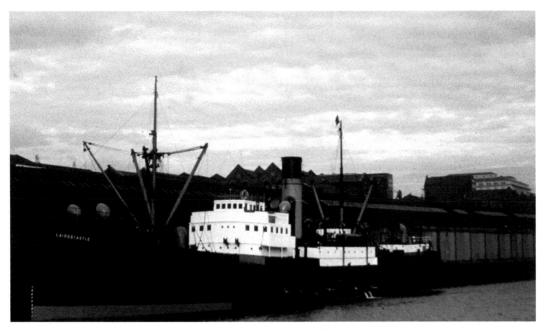

Lairtdscastle (1919/1,390 grt) was built as *War Leven*, becoming *Limoges* in 1919, *Western Coast* in 1922, *Meath* in 1946 and *Lairdscastle* in 1952. It was broken up in 1958.

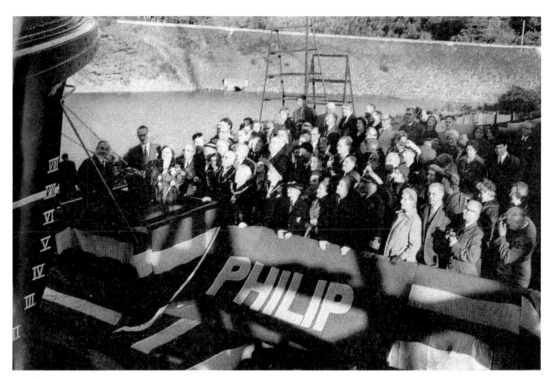

Above and below: Woodchurch was launched for Birkenhead Corporation on 29 October 1959 at Dartmouth.

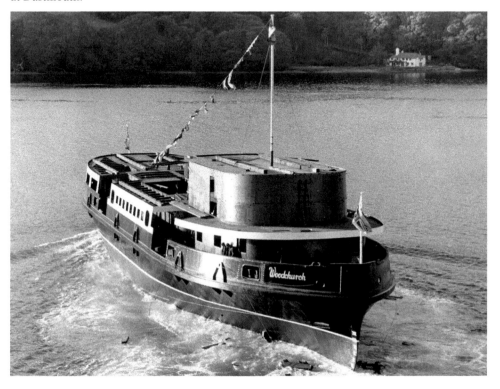

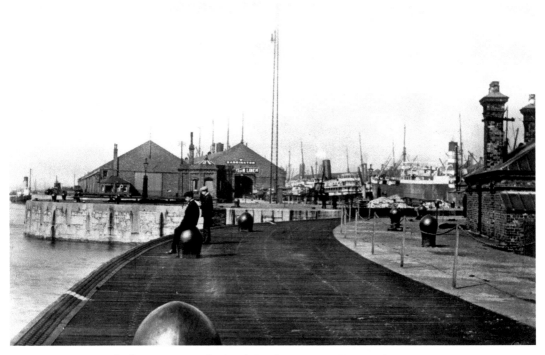

Harrington Dock, the entrance to the South Docks system at Liverpool.

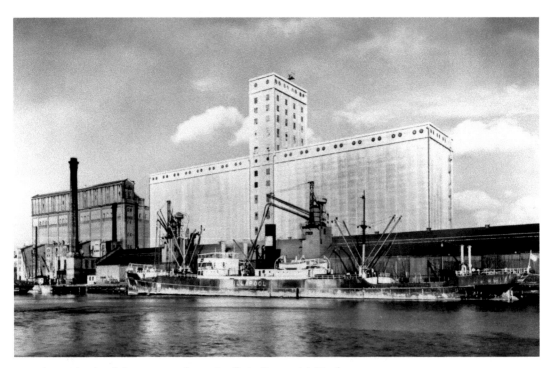

A vessel unloads its cargo at the grain silo in Brunswick Dock.

ANCHOR LINE

BOMBAY

ALSO

PORT SAID · ADEN · *KARACHI

"CALEDONIA"

CLOSING FOR CARGO

BIRKENHEAD	**30th MARCH**
EAST QUAY, EAST FLOAT	

★ KARACHI CARGO BY SPECIAL ARRANGEMENT ONLY

Vessel has liberty to call at other U.K. Ports and at other Ports either on or out of route

Intending shippers wishing to ship cargo by this vessel should make application for space on the appropriate form which can be obtained and lodged at any of our offices.

Shipper must not despatch cargo to vessels until receipt of calling forward notice, and it is essential that shippers and suppliers should adhere to the delivery dates shown on such notices.

Goods insured on the most favourable terms.

All packages must be distinctly port marked.

All cargo received and shipped subject to terms and conditions of shipping notes, wharfingers receipts, and bills of lading.

February, 1961

BOOTH LINE

NORTH BRAZIL MAIL STEAMERS

M.V. **"BEDE"**

SAILING FROM LONDON 11th FEBRUARY, 1961
SAILING FROM LIVERPOOL 23rd FEBRUARY, 1961

Accepting cargo for

LEIXOES LISBÔN
LAS PALMAS FORTALEZA
PARNAÍBA AND SÃO LUIS

LIVERPOOL RECEIVING DATES
7th FEBRUARY to 21st FEBRUARY, 1961

at S.E. 2 Queen's Dock

FOR DETAILS OF LONDON RECEIVING DATES AND LOADING BERTH, PLEASE APPLY TO OUR LONDON AGENTS.

REFRIGERATOR SPACE AVAILABLE

Following Vessel M.V. "BASIL" Loading March, 1961

For further particulars apply to:—

THE BOOTH STEAMSHIP CO. LTD., Cunard Building, Liverpool 3
Telephone No. CENtral 9181

LAMPORT AND HOLT LINE LTD., 31/33 Lime Street, London E.C.3
Telephone No. Mansion House 7533

26th January, 1961 P.T.O.

Above left: Anchor Line sailing list for February 1961.

Above right: Booth Line sailing list for January 1961.

Below: Guinea Gulf Line's *Elizabeth Holt* (1953/5,580 grt) is assisted into Brunswick Dock by a 'Cock' tug. It became *Admiralty Crest* and *Despina N* in 1965 and *Lorain* in 1973. It was broken up at Kaohsiung in 1973.

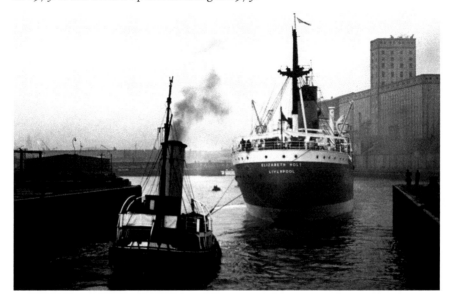

Tugs prepare to 'lock out' at Waterloo entrance.

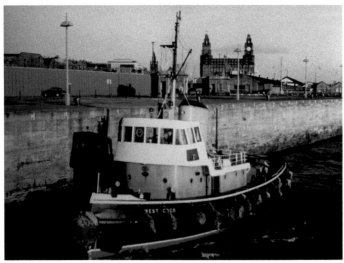

West Cock (1958/192 grt) at Waterloo entrance. It was renamed *Morpeth* in 1970 and *Vernicos Giannis* in 1981. In August 1983 it was involved in a collision and sank.

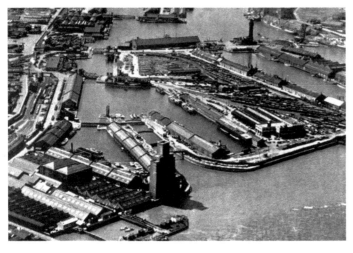

Morpeth Dock, Birkenhead.

Greek Line's *Arkadia* (1931/22,424 grt) in Grayson, Rollo and Clover's drydock at Woodside. It was built as *Monarch of Bermuda*, becoming *New Australia* in 1949 and *Arkadia* in 1958. It was broken up in 1966.

Two Clan Line vessels anchored in the river prior to entering Birkenhead Docks to load cargo at Vittoria Dock.

The Cunard liner *Saxonia* (1954/22,592 grt) sails on its maiden voyage from Liverpool to Quebec and Montreal on 2 September 1954. It was renamed *Carmania* in 1963 and *Leonid Sobinov* in 1973. It arrived at Alang on 1 October 1999 and was broken up.

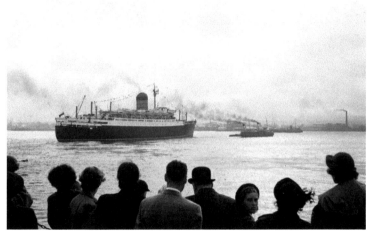

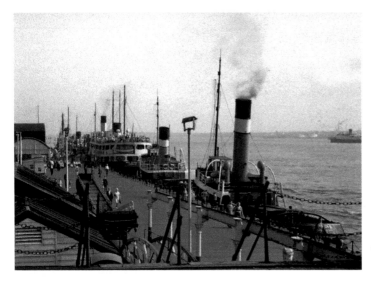

Tugs and Mersey ferries at Liverpool Landing Stage.

Clan Brodie (1941/7,473 grt) was completed as an aircraft transport, becoming *Clan Brodie* in 1946. It arrived at Hong Kong on 19 July 1963 and was broken up.

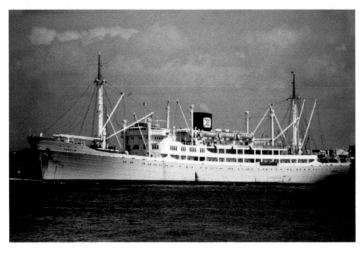

Booth Line's *Anselm* (1950/10,946 grt) was launched as Baudouinville, becoming *Thysville* in 1957, *Anselm* in 1961, *Iberia Star* in 1963 and *Australasia* in 1965. It was broken up in 1973.

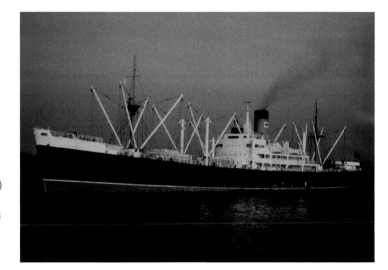

Pipiriki (1944/10,057 grt) operated on the service from the United Kingdom to Australia. It arrived at Kaohsiung on 3 February 1971 and was broken up.

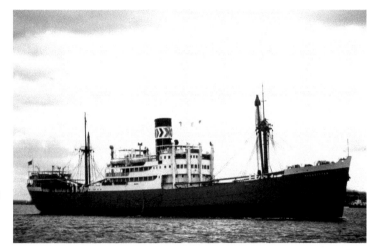

Strick Line's *Nigaristan* (1947/7,173 grt) became *Astromar* in 1967 and *Aris* two years later. It arrived at Shanghai on 7 October 1971 and was broken up.

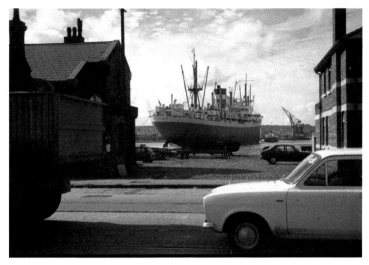

City of Birmingham (1949/7,577 grt) was owned by the Ellerman Lines. It arrived at Castellon on 9 October 1971 and was broken up.

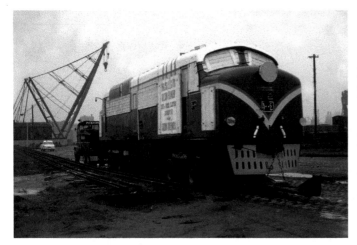

Pickford's deliver a diesel electric locomotive from the Vulcan Foundry to Cavendish Quay, where it would be lifted on to the deck of a vessel sailing to Sudan. The locomotive was to be shipped to Sudan Railways. The crane in the photograph was used to lift heavy loads on to vessels and then carried to their destination as deck cargo.

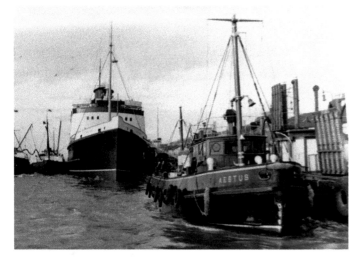

Left: Aestus (1949/95 grt) was built by W. J. Yarwood at Northwich as a survey vessel for the Mersey Docks & Harbour Board. It was broken up at Birkenhead in 1999.

Below: HMS *Pollington* (M1173) at Liverpool Landing Stage.

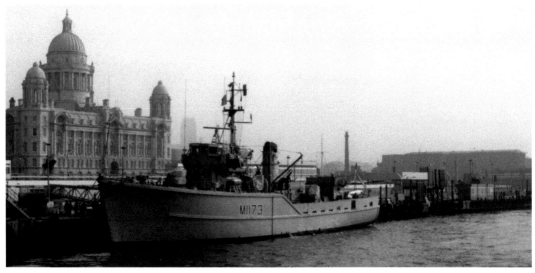

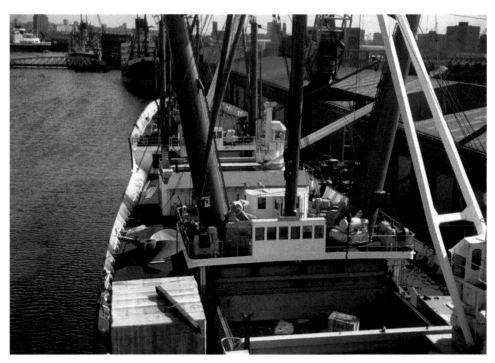

Protesilaus (1967/12,094 grt) loading cargo at Vittoria Dock. It became *Oriental Importer* in 1978, and arrived at Kaohsiung on 18 September 1985 and was broken up.

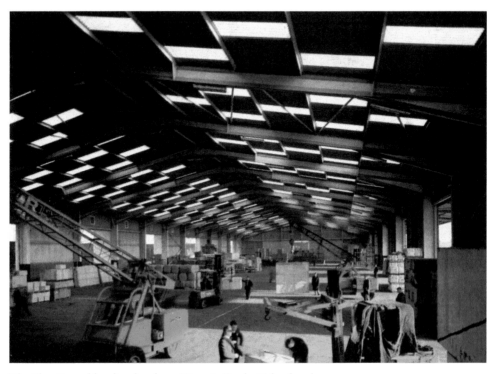

The Blue Funnel loading berths at Vittoria Dock, Birkenhead.

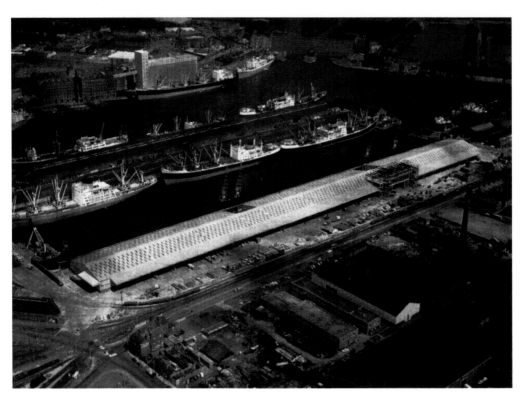

Above: The new warehouses at Vittoria Dock, Birkenhead, were built in the 1960s. Unfortunately, they had a very short life as container ships were taking over from the conventional cargo vessels, which operated on routes from Birkenhead Docks.

Left: Following the closure of conventional cargo services from Birkenhead the floating crane *Mammoth* moves the 6-ton cranes from Vittoria Dock at Birkenhead across the river to Canada Dock in Liverpool on 12 May 1982.

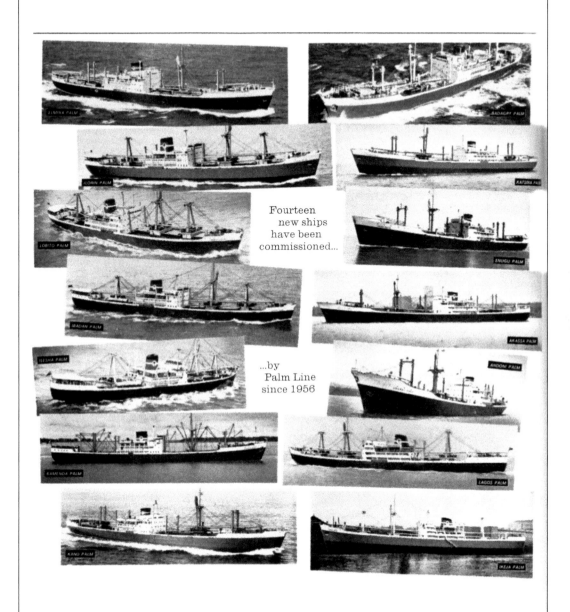

Fourteen
new ships
have been
commissioned...

...by
Palm Line
since 1956

THE MODERN CARGO LINE SERVING WEST AFRICA

1963 Palm Line advertisement.

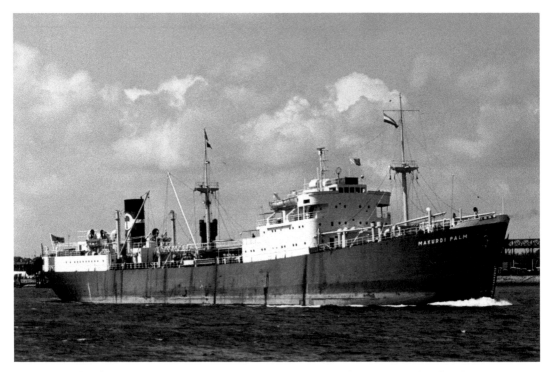

Makurdi Palm (1953/6,178 grt) was launched as *Tema Palm*, becoming *Makurdi Palm* in 1961 and *Santamar* in 1969. It was broken up at Gadani Beach in 1976.

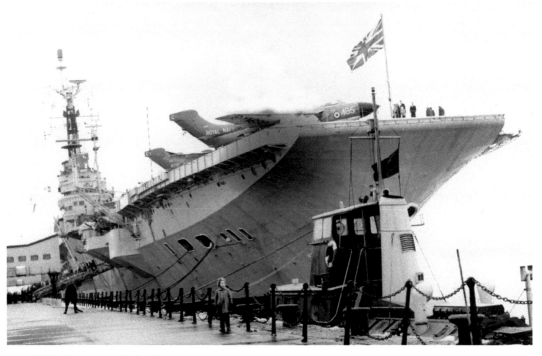

HMS *Centaur* at the landing stage.

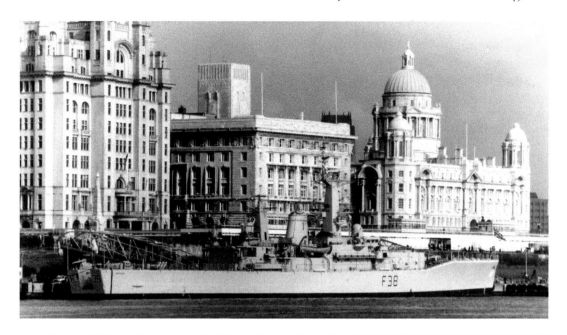

Above: HMS *Arethusa* at the Pier Head. It was a Leander class frigate commissioned on 24 November 1965, and sank as a target in 1991.

Right: 1961 Escombe McGrath sailing list.

27th January, 1961			No. 347	
ESCOMBE, McGRATH & CO. LTD. LIVERPOOL.				
FORTNIGHTLY SHIPPING LIST.				
IMPORTANT.—Shippers must NOT despatch cargo to any vessels until receipt of Calling Forward Notice from us.				
PORT	STEAMER	Approx. date of Closing	LINE	Loading at
CALCUTTA	Indian Success	Feb. 3	India	Birkenhead
	Jala Jag Jiwan	Feb. 8	Scindia	Birkenhead
	Makalla	Feb. 9	Brocklebank	Birkenhead
	City of Hereford	Feb. 22	City	Birkenhead
BOMBAY	Sacramento	Feb. 1	Hall	Birkenhead
	Jalanthony	Feb. 3	Scindia	Birkenhead
	Cilicia	Feb. 3	Anchor	Birkenhead
	Bassano	Feb. 15	Hall	Birkenhead
KARACHI	Sacramento	Feb 1	Hall	Birkenhead
	Jalanthony	Feb. 3	Scindia	Birkenhead
	Bassano	Feb. 15	Hall	Birkenhead
MADRAS	Indian Success	Feb. 3	India	Birkenhead
	Jala Jag Jiwan	Feb. 8	Scindia	Birkenhead
	Clan Mackellar	Feb. 17	Clan	Birkenhead
COLOMBO	Warwickshire	Feb. 4	Bibby	Birkenhead
	Clan Mackinnon	Feb. 18	Clan	Birkenhead
RANGOON	Warwickshire	Feb. 4	Bibby	Birkenhead
	Prome	Feb. 14	Henderson	Birkenhead
JEDDAH, PENANG, PRAI, PORT SWETTENHAM, INDONESIA	Antilochus	Feb. 3	Holt	Birkenhead
SINGAPORE, BANGKOK, HONG KONG, MANILA	Menestheus	Feb. 8	Holt	Birkenhead
PENANG, PRAI, PORT SWETTENHAM, SINGAPORE, HONG KONG, JAPAN, PUSAN	Menelaus	Feb. 15	Holt	Birkenhead
SINGAPORE, BANGKOK LABUAN, MANILA, SHANGHAI	Demodocus	Feb. 15	Holt	Birkenhead
PENANG, PRAI, PORT SWETTENHAM, SINGAPORE, HONG KONG, KOBE	Atreus	Feb. 21	Holt	Birkenhead
PENANG, PRAI, PORT SWETTENHAM, SINGAPORE, HONG KONG, HSINKANG	Dolius	Feb. 24	Holt	Birkenhead
AUSTRALIA Fremantle, Adelaide, Melbourne Sydney, Brisbane	Ixion	Feb. 3	Gracie	Liverpool
	Auckland Star	Feb. 10	Marwood	Liverpool
NEW ZEALAND *Auckland, Dunedin †Wellington, Lyttelton, Napier	*Cambridge	Feb. 10	Dowie	Liverpool
	†Cumberland	Feb. 10	Dowie	Liverpool
EAST AFRICA	Clan Mackinlay	Feb. 8	Staveley	Birkenhead
	City of Durham	Feb. 22	Staveley	Birkenhead
LA GUAIRA, PUERTO CABELLO, CURACAO, MARACAIBO	Craftsman	Feb. 3	Harrison	Liverpool
	Historian	Feb. 17	Harrison	Liverpool
TRINIDAD & BARBADOS	Indiana	Feb. 2	Saguenay	Liverpool
	Craftsman	Feb. 7	Harrison	Liverpool
	K.C. Rogenaes	Feb. 14	Saguenay	Liverpool
KINGSTON & MEXICO	Factor	Jan. 31	Harrison	Liverpool
	Adventurer	Feb. 14	Harrison	Liverpool
DEMERARA	Indiana	Feb. 2	Saguenay	Liverpool
	K.C. Rogenaes	Feb. 14	Saguenay	Liverpool
COLOMBIA, ECUADOR, PERU & CHILE	Pizarro	Feb. 2	P.S.N.C.	Liverpool
	Essequibo	Feb. 18	P.S.N.C.	Liverpool
DURBAN, LOURENCO MARQUES, BEIRA	City of London	Feb. 10	Staveley	Birkenhead
	Clan Macdonald	Feb. 21	Clan	Birkenhead
	Canberra Star	Feb. 23	Blue Star	Liverpool
CAPE TOWN, PT. ELIZABETH EAST LONDON *Takes Lobito & Mauritius	*Clan Ross	Feb. 3	Clan	Birkenhead
	Clan MacInnes	Feb. 14	Clan	Birkenhead
	Canberra Star	Feb. 23	Blue Star	Liverpool
OTHER PORTS. Particulars can be obtained upon application to us.				
ALL SAILINGS ARE SUBJECT TO ALTERATION OR CANCELLATION WITHOUT NOTICE				
For Rates of Freight, Insurance and Passage, apply to :— 'PHONE: CENTRAL 2672-4				
ESCOMBE, McGRATH & CO. LTD., 14 Water St., Liverpool 2.				
LONDON : 4 Lloyd's Avenue, E.C. 3. (Head Office). BIRMINGHAM: Royal London House, 35 Paradise St. GLASGOW: 56 West Nile Street, C. 1.		GRIMSBY: 99 Cleethorpe Road. MANCHESTER 3 : Albert Square, 2. MIDDLESBRO.-ON-TEES: Zetland Buildings. SOUTHAMPTON : Canute Road.		
PASSENGER AGENTS FOR ALL THE PRINCIPAL STEAMSHIP & AIR LINES				

SEASON 1966

SPECIAL EXCURSIONS BY SEA FROM

LIVERPOOL
TO
MENAI BRIDGE

and ALONG THE
ANGLESEY COAST

Cruise along the Anglesey Coast

On Sunday July 31st.

Passengers leave Liverpool by the Isle of Man Steam Packet Vessel at 11.15 a.m. arriving at Llandudno at 1.30 p.m. They proceed from Llandudno Pier by Messrs. P. & A. Campbell's M.V. St. Trillo at 2.30 p.m. for a cruise along the **Anglesey Coast.** This cruise passes the Great Orme, Puffin Island and crosses Red Wharf Bay towards Point Lynas arriving back at Llandudno at 5.30 p.m. The return steamer for Liverpool leaves Llandudno at 7.0 p.m. and reaches Liverpool about 9.15 p.m.

Inclusive fare 28/6d. (Children under 14 half fare)

To Menai Bridge

On Tuesday August 16th.

Passengers leave Liverpool by the Isle of Man Steam Packet Vessel at 10.45 a.m. for Llandudno due 1.0 p.m. They proceed from Llandudno Pier by Messrs. P. & A. Campbell's M.V. St. Trillo at 2.30 p.m. to **Menai Bridge,** where they will arrive about 4.0 p.m. Return from Menai Bridge at 4.30 p.m. for Llandudno where they will arrive at 6.0 p.m. and leave Llandudno by the Isle of Man Company's vessel for Liverpool at 7.30 p.m. The vessel will arrive at Liverpool about 9.45 p.m.

Inclusive fare 32/- (Children under 14 half fare)

For General Information and Conditions of Carriage—see over

Left: 1966 St Trillo Liverpool to Menai Bridge leaflet.

Below: The Cunard freight and passenger liner *Media* (1947/13,345 grt) at the landing stage.

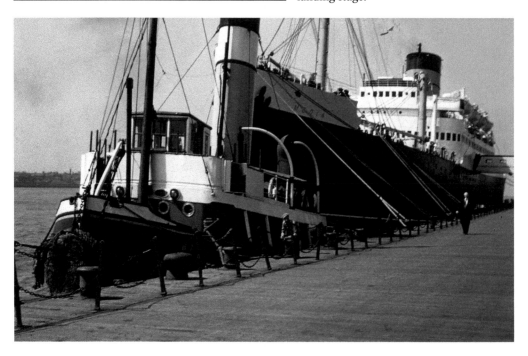

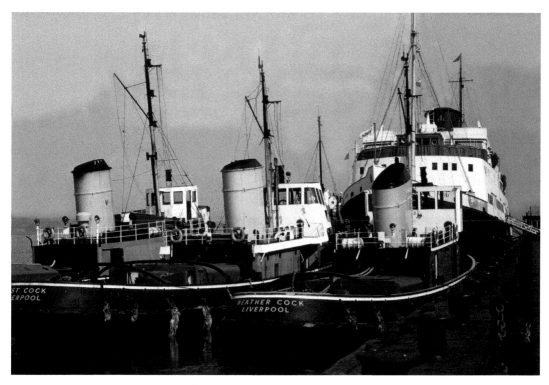

Manxman (1955/2,495 grt) and 'Cock' tugs at the Pier Head.

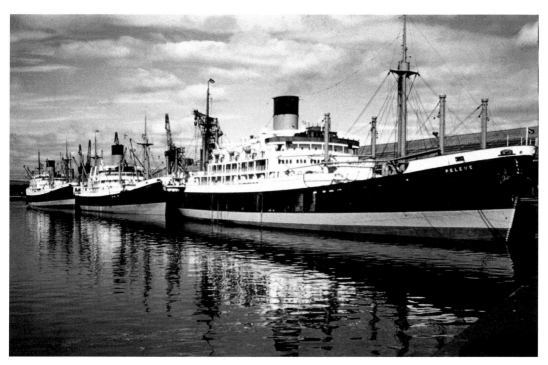

Blue Funnel vessels loading cargo at Vittoria Dock, Birkenhead.

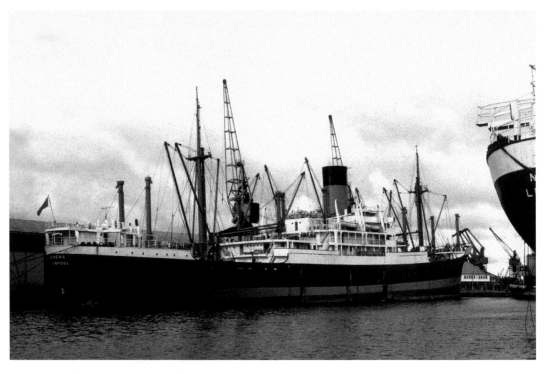

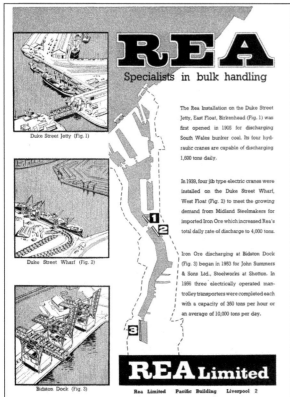

Above: *Aeneas* (1947/8,295 grt) at Vittoria Dock.

Left: Rea Limited advertisement showing the berths at Cavendish Quay, Birkenhead and Bidston Dock.

Indian Glory
(1978/13,482 grt) at
Cavendish Quay.

Rea Limited locomotives
at Bidston Dock.

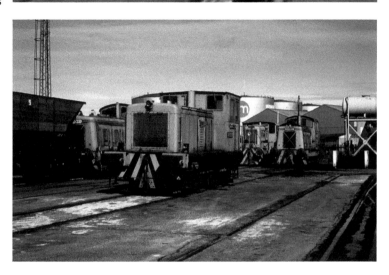

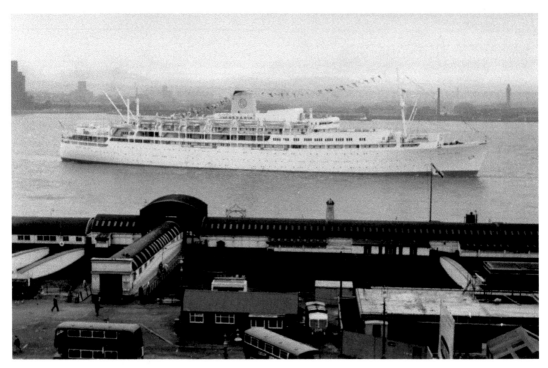

The *Reina Del Mar* (1956/20,234 grt) approaching Liverpool Landing Stage.

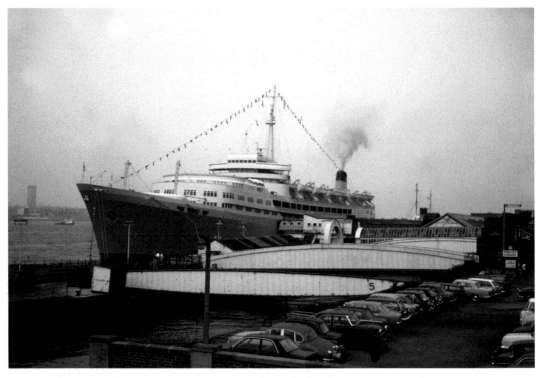

Southern Cross (1955/20,204 grt) prepares to leave the landing stage on a Mediterranean cruise.

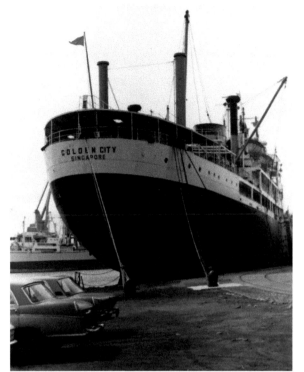

Right: *Clan Macilwraith* (1960/6,894 grt) is renamed *Golden City* at Birkenhead on 23 April 1979.

Below: A new propellor is lifted from the quay at the West Float on 3 March 1982. It was claimed to be the world's largest propeller as it was 11 metres in diameter, weighing 69 tons.

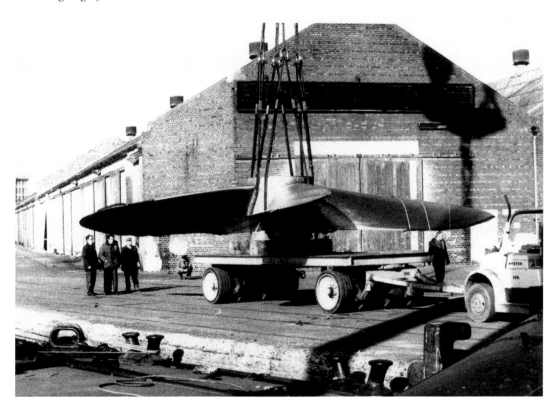

The iron-ore-discharging berth at Bidston Dock, Birkenhead.

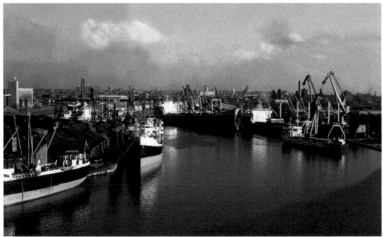

The West Float at Birkenhead.

Waterloo Container Terminal was operated by the B+I Line.

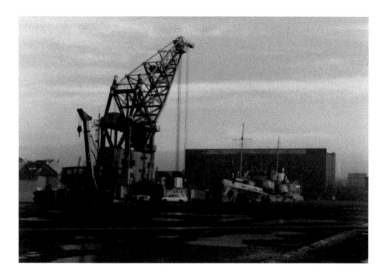

The floating crane *Samson* (1960/774 grt) and dredger *Mersey No. 40* (1957/1,968 grt) in Brocklebank Dock.

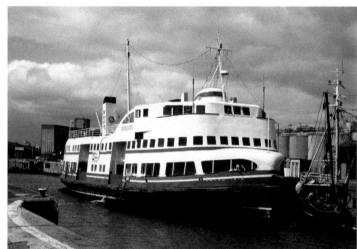

Royal Iris (1951/1,234 grt) in Alfred Dock, Birkenhead.

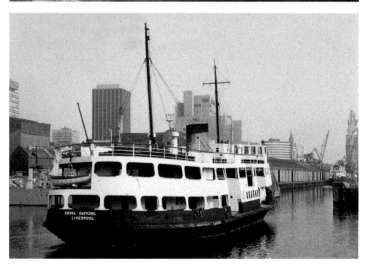

Royal Daffodil (1958/609 grt) entering Prince's Dock.

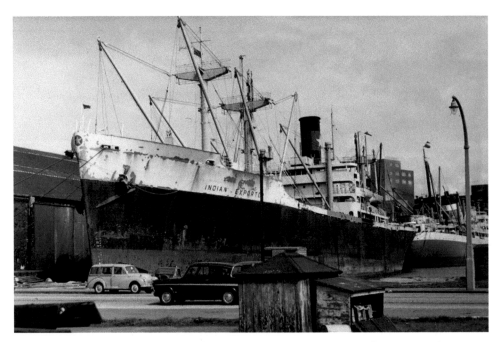

Indian Exporter (1945/7,606 grt) in the East Float, berthed next to Duke Street Bridge. It was launched as *Temple Victory*, becoming *Indian Exporter* in 1947 and *Samudra Usha* in 1972. It was broken up at Bombay in 1977.

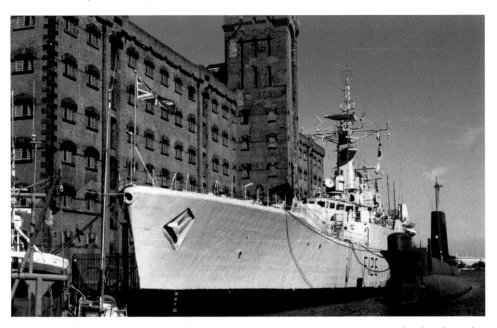

The Historic Warship Collection was an important tourist attraction in Birkenhead Docks, incorporating some significant ships. It was situated in the East Float next to some Victorian grain warehouses and was a popular destination for visitors to the area. The collection consisted of the submarine HMS *Onyx*, HMS *Plymouth*, HMS *Bronington*, the landing craft, Tank LCT 7074 and the German U-boat U534.

Garston Docks

A small dock was first built at Garston in 1793 for Blackburne's saltworks, which had moved out of Liverpool as it needed more space. Garston Docks is now operated by Associated British Ports and was built by the St Helens and Runcorn Gap Railway Company, and the first dock, the Old Dock, was opened on 21 June 1853. The port was taken over by the London & North Western Railway, and the London Midland & Scottish Railway in 1921. When British Railways was formed they assumed responsibility for the port. The management of the port passed to the British Transport Commission and later Associated British Ports. It was originally intended to use the port to specialise in loading and unloading coal. The docks cover 6 acres (24,000 sq metres) and 250 tons of coal could be loaded in two and a half hours. In 1870 a new railway line to Wigan was opened, linking Wigan coalfields to Garston Docks. The North Dock was opened in 1876, the Stalbridge Dock in 1909 and Garston Docks was soon dealing almost half of the coal trade imported into Liverpool. Elders and Fyffes also established the trade of importing bananas from the West Indies through the port. The company once dealt with over 50 per cent of imports of bananas to the United Kingdom at Garston, but imports were transferred to Southampton in the 1960s. Various other industries were developed alongside the docks such as the Graving Dock, the J. M. Mills distillery, Garston Tanning Company, Francis Morton Company Limited iron and steel works, and the Wilson Brothers Bobbin Company Limited.

The dock system contains the Old Dock, North Dock and Stalbridge Dock, comprising 28.5 acres of water, 70 miles of sidings, 80 acres of storage and deals with around 2 million tons of goods a year. The port contributes over £350 million to the United Kingdom economy each year and offers dry bulk storage for a range of cargoes including grain, ores and sand. Agriculture products including soya, wheat and fertiliser are imported and construction materials such as aggregates for building projects are also handled at the port. Other regular imports are cement, coal and steel. Firms using the Port of Garston include Hanson, Tarmac, Premier Cement, Peacock Salt, Simms Metal Management and the shipping agent Frank Armitt. Between 2016 and 2017 Associated British Ports spent several million pounds upgrading the port, investing £3 million on new lock gates, £2.2 million on sheds and buildings and £1.8 million on a new crane.

Sailing ships and steam vessels berthed at Garston Docks.

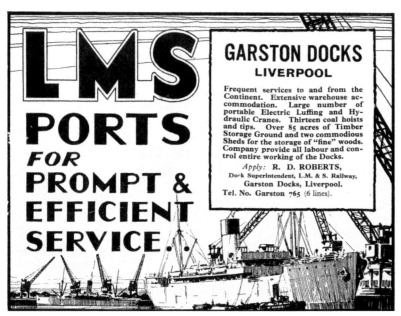

GARSTON DOCKS
LIVERPOOL

Frequent services to and from the Continent. Extensive warehouse accommodation. Large number of portable Electric Luffing and Hydraulic Cranes. Thirteen coal hoists and tips. Over 85 acres of Timber Storage Ground and two commodious Sheds for the storage of "fine" woods. Company provide all labour and control entire working of the Docks.

Apply: R. D. ROBERTS,
Dock Superintendent, L.M. & S. Railway,
Garston Docks, Liverpool.
Tel. No. Garston 765 (6 lines).

Left: 1936 advertisement for Garston Docks.

Below: Advertisement for Garston Docks.

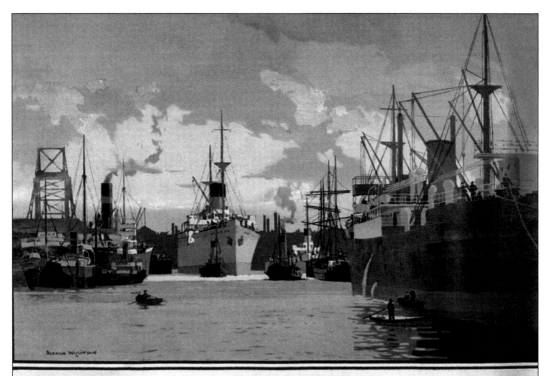

GARSTON
THE LMS MERSEYSIDE PORT
By NORMAN WILKINSON, R.I.

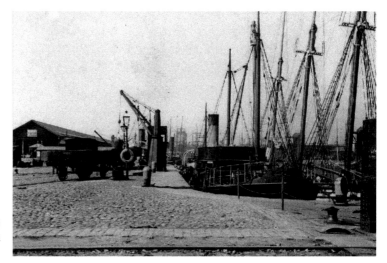

A rail wagon waits for its cargo to be loaded onto a vessel at Garston Docks.

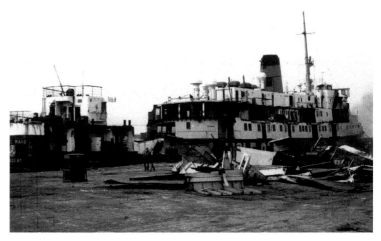

Manx Maid (1962/2,724 grt) arrived at Garston on 11 February 1986 and was broken up by C. R. Massie.

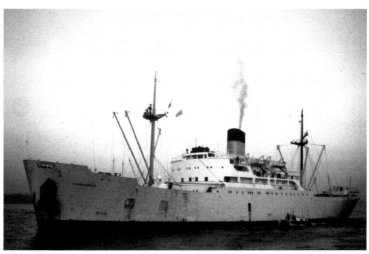

Changuinola (1957/6,283 grt) was a regular visitor to Garston Docks. It was owned by Elders & Fyffes and carried bananas.

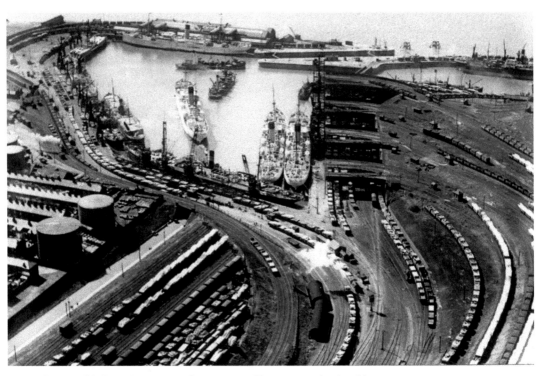

Above and below: Garston Docks was served by a network of rail lines.

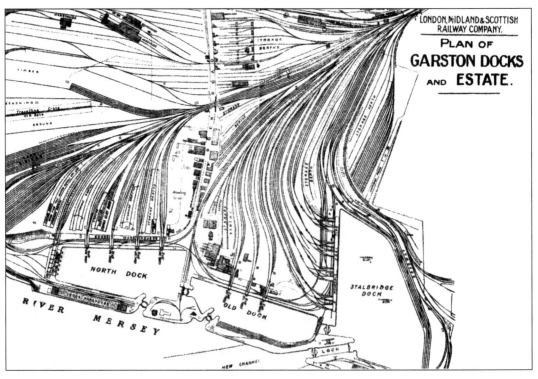

A cargo of timber is unloaded on to the quayside at Garston Docks.

Eastham

Eastham is the entrance to the Manchester Ship Canal, which is 36 miles long and was divided into eight sections. Work began in 1887 at Eastham, Warrington, Warburton and Salford and a railway track was laid along the route of the canal to distribute materials and take away rock and soil. A train ran the full length each day. In 1892 a wharf was constructed at Ellesmere Port to handle traffic on the Manchester Ship Canal. Runcorn Docks is owned by Peel Ports as part of the Manchester Ship Canal and comprises of Francis Dock, Alfred Dock and Fenton Dock, and the Port of Weston is operated by the Stobart Group. It has been claimed that the construction of the Manchester Ship Canal was the greatest engineering project of Victorian times.

Eastham is one of the oldest villages on the Wirral and has been inhabited since Anglo-Saxon times. The name derives from 'ham' ('home'), situated east of Willaston, which was the main settlement. St Mary's Church is at the centre of the village and the grounds contain an ancient yew tree. A ferry service operated across the river to Liverpool since the Middle Ages, and was originally run by the monks from the Abbey of St Werburgh. Paddle steamers were later introduced to replace the earlier sailing vessels. However, the demand for the service declined with the opening of a railway service between Chester and Birkenhead in 1846.

The canal was opened by Queen Victoria on 21 May 1894 and a Jubilee Arch was built in 1897 to commemorate the Queen's Diamond Jubilee. The Eastham Ferry Hotel was built by Thomas Stanley and the Pleasure Gardens were later added to attract visitors to the town. In the summer months people were entertained by acts like Blondin, who was a tightrope walker, and in 1894 he wheeled a local boy across a high wire in a wheelbarrow. The ferry steamers continued until 1929 and the pleasure gardens fell into disrepair during the 1930s. The iron pier and Jubilee Arch were dismantled in 1970 and the area was designated a country park. Torr Park is situated in the centre of the village. It was founded by the Stanley family and is home to the village cricket club. The Queen Elizabeth II Dock was built in 1954 and has its own entrance lock. The lock is 807 feet long and 100 feet wide, with a single sliding gate at each end. An extra gate about a third of the way from the entrance to the Mersey was built, and all three slide into the lock wall. The dock was built with four berths, each capable of handling oil tankers of up to 30,000 gross tons. However, this dock soon proved inadequate for the tankers, which were being introduced and a river berth was built at Tranmere. A pipeline was also provided from another berth off Anglesey, where oil is discharged.

The National Waterways Museum, formally known as the Boat Museum, is located at Ellesmere Port. The town was originally the entrance to the Ellesmere Canal. The canal was designed and engineered by William Jessop and Thomas Telford, and the section between the River Mersey at Netherpool and the River Dee at Chester was opened n 1795. The village of Netherpool changed its name to the Port of Ellesmere, and to Ellesmere Port by the early nineteenth century. The first houses in Ellesmere Port were built around the docks and the first main street was Dock Street. In 1892 a new wharf was built to handle traffic

on the Manchester Ship Canal. Burnell's Iron Works and the Wolverhampton Corrugated Iron Company established manufacturing units at the beginning of the twentieth century. Around 300 workers and their families came from Wolverhampton to work in Ellesmere Port, and as more industry was established the town continued to expand. In 1921 the docks were leased to the Manchester Ship Canal. The docks were reopened in 2007 and are subject to planning consultation, which may see them redeveloped into a predominantly residential area.

Runcorn and Weston Point are also independent ports in their own right, and Widnes West Bank Dock is another small port that handles coastal traffic. Transport links to these ports were improved when the Runcorn–Widnes high-level road bridge was opened in 1961, replacing the outmoded transporter bridge that had linked the two towns since 1905. At the beginning of the nineteenth century Telford proposed a 1,000-foot-span cable suspension bridge, which would have had a clearance of 70 feet above high-water level and provided a road 20 feet wide. Between 1863 and 1868 the London & North Western Railway constructed a bridge with three clear spans of about 300 feet, and capable of taking heavy modern railway traffic. The 1,000-foot-span transporter bridge was built in 1905 at a cost of £137,663 6s 4d. and was able to make 150 journeys a day, carrying an average of 200 passengers an hour on its five-minute trip across the river and the Manchester Ship Canal. The bridge, which opened in 1961, is 1,628 feet long with a central arch span of 1,082 feet between the main bearings. This bridge is still in use but a new crossing was opened in 2017 and both are operated by a toll system.

Navigation on the upper reaches of the Mersey can be traced back for over two centuries with vessels navigating from Liverpool as far as Warrington, but beyond that point its bends, shallows and mud banks make it impossible to navigate any further. The Mersey and Irwell Navigation Act of 1720 enabled vessels to navigate to Manchester using the Mersey and Irwell. Work on the Bridgewater Canal commenced in 1759 and it was opened on 17 July 1761. It originally ran from Worsley to Salford but was extended through Cheshire to link Manchester with the Upper Mersey estuary at Runcorn, where docks were built in the 1760s. Weston Point Docks followed in 1820, when the Weaver Navigation was extended by the building of the Weston Canal, which gave access to Weston Point and the River Mersey.

The Bridgewater Trustees administered the docks but also the duke's coal mining interests, and the navigation section of the trusteeship was sold to the Bridgewater Navigation Company Limited in 1872. Three lighthouses were built, one at Hale Head, one at Garston and another at Ince, on the Cheshire bank. Hale lighthouse light was discontinued on 1 April 1958, Ince light disappeared during the construction of the Manchester Ship Canal, and the light at Garston was discontinued when the railway docks were developed. The Upper Mersey Navigation Commission was established on 1 January 1877 with responsibility for the provision and maintenance of buoys, beacons, lighthouses, lightships and lights for the area of the Upper Mersey, and for levying of dues on vessels using the river. When the Manchester Ship Canal was constructed, it was necessary for statutory right of free passage to Runcorn and Weston Point to be preserved. Weston Mersey Lock, Bridgewater Lock and Old Quay Lock were constructed to enable craft passage from the river into the Ship Canal and to Runcorn and Weston Point Docks and the Weaver Navigation. West Bank Dock at Widnes was built around 1854 by John Hutchinson, who founded the alkali industry in Widnes, and a new lock was opened in 1916. For many years the main traffic passing through this dock was sand, granite dust and chippings, fertilisers and asbestos cement products, bauxite ore, timber, salt and general cargo.

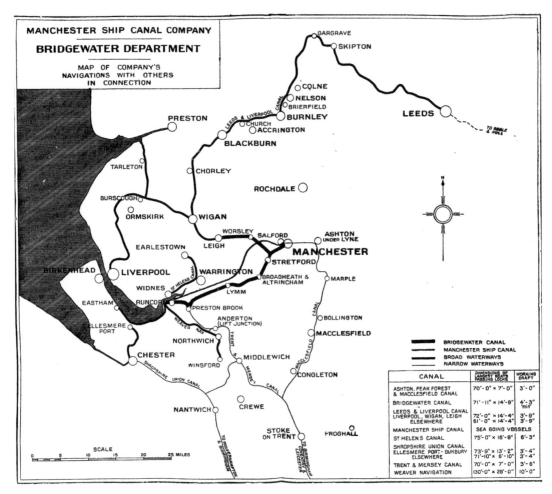

Map of the Manchester Ship Canal.

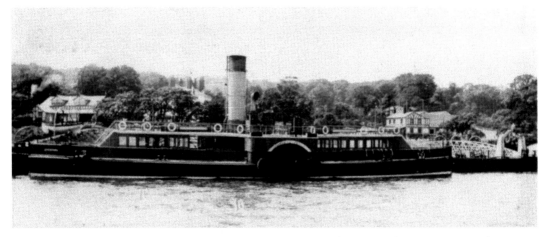

The Eastham ferry *Liverpool* (1907/487 grt) operated on the service between Liverpool Pier Head and Eastham.

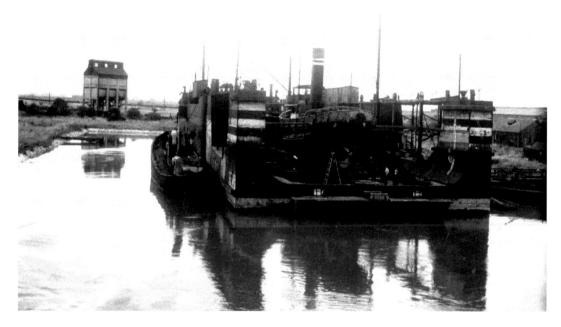

Above: The Floating
Pontoon Dock at Ellesmere
Port.

Right: Dredging work
is carried out in the
Manchester Ship Canal.

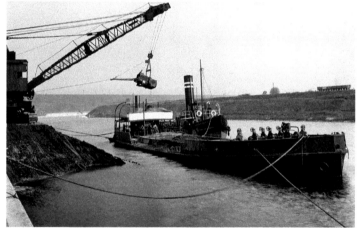

Dakarian (1921/6,427 grt)
in the Manchester Ship
Canal. It was laid down
as *Dahovian*, becoming
Benvannoch in 1939,
Birchbank in 1946, *Shunkei
Maru* in 1952 and *Indus
Maru* in 1955. It was
broken up in 1958.

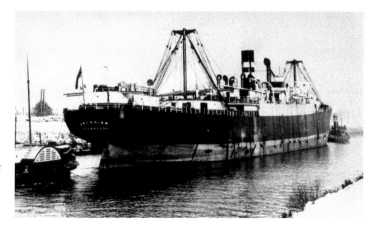

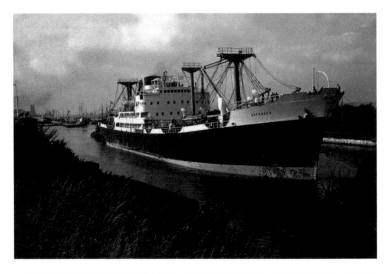

Defender
(1955/8,367 grt) was
renamed *Euromariner* in
1975, and was broken
up in 1977.

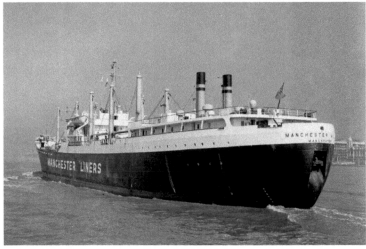

Manchester Miller
(1959/9,297 grt) was
renamed *Manchester
Quest* in 1970, and was
broken up in 1976.

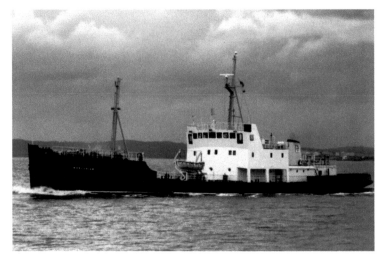

The sludge disposal vessel
Mancunian (1946/1,378 grt).

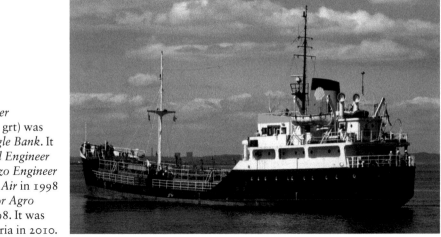

Shell Engineer
(1966/1,177 grt) was
built as *Dingle Bank*. It
became *Shell Engineer*
in 1979, *Gozo Engineer*
in 1990, *Bel Air* in 1998
and *Hensmor Agro
Allide* in 1998. It was
lost off Nigeria in 2010.

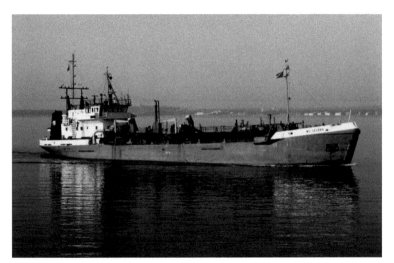

*Westminster
Dredging W D Severn*
(1974/1,318 grt).

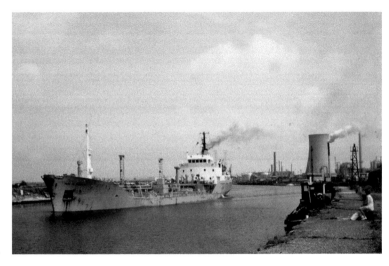

Pass of Balmaha
(1975/2,334 grt) in the
Manchester Ship Canal.

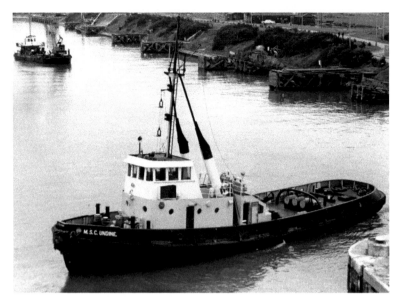

MSC *Undine*
(1965/127 grt)

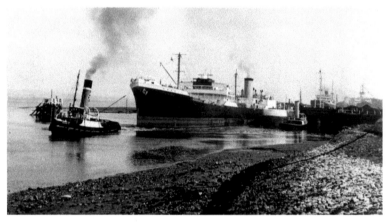

The Shell tanker *Circe
Shell* (1931/8,207
grt) leaving Eastham.
It was sunk by U-161
on 21 February 1942
on a voyage from
Glasgow to Curacao
in ballast.

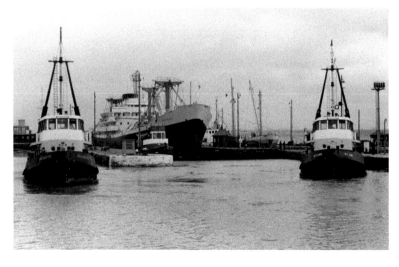

The Harrison
Line cargo
vessel *Plainsman*
(1959/8,732 grt)
at Eastham. It was
renamed *Evlalia* in
1979, and was broken
up in 1985.

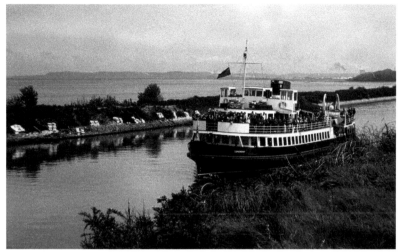

The Wallasey Corporation ferry *Egremont* (1952/566 grt) on a cruise along the Manchester Ship Canal. It became a floating clubhouse at Salcombe, Devon, in June 1976.

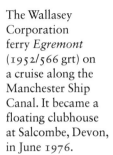

MSC Badger (1939/144 grt) was launched on 8 March 1939 by Henry Robb at Leith.

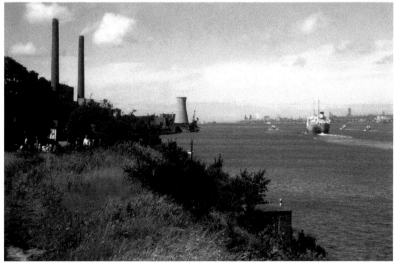

Regent Caribou (1951/12,072 grt) heads for the open sea after discharging its cargo at Eastham. It was renamed *Gonzalo* in 1966, and was broken up two years later.

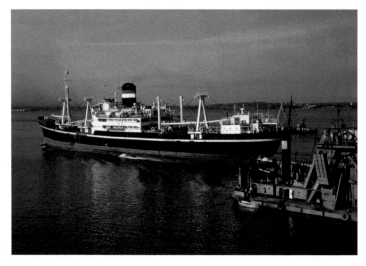

The Brocklebank cargo
vessel *Makrana* (1957/8,764
grt) leaving Eastham. It was
renamed *Aegis Glory* and
Aegis Eternity in 1971, and
was broken up at Shanghai
in 1974.

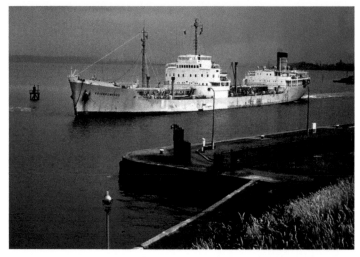

Keizerswaard (1955/12,576
grt) leaving Eastham. It
became *Ionic King* in 1970,
Halcyon Cove in 1973
and *Rania* in 1974. It was
broken up at Gadani Beach
in 1976.

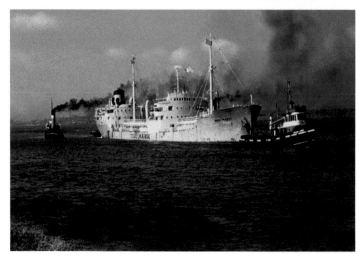

Tove Maersk (1954/8,456
grt) assisted by Lamey
tugs arrives at Eastham. It
became Equatorial in 1967,
and was broken up in 1975.

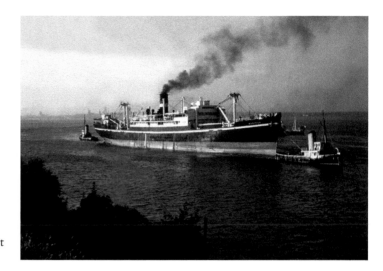

Manipur (1945/8,569 grt) arriving at Eastham. It was broken up in 1967 at Whampoa.

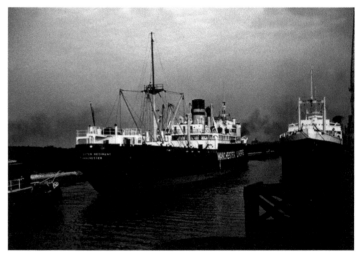

Manchester Regiment (1947/5,888 grt) became *Azure Coast II* in 1967 and *Pu Gor* in 1970. It arrived at Kaohsiung on 24 Novemeber 1971 and was broken up.

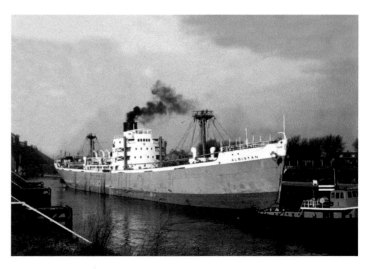

Strick Line's *Albistan* (1948/5,516 grt) in the Manchester Ship Canal. It was broken up at Hong Kong in 1971.

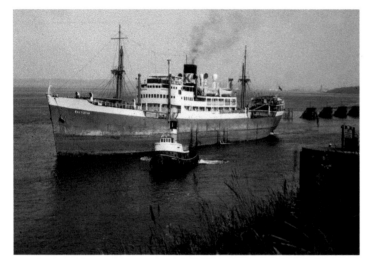

Baltistan (1953/7,489 grt) was also owned by the Strick Line. It was renamed *Elinda* in 1972 and *Gulf Diamond* the following year. It was wrecked on 20 May 1974, and broken up at Gadani Beach later that year.

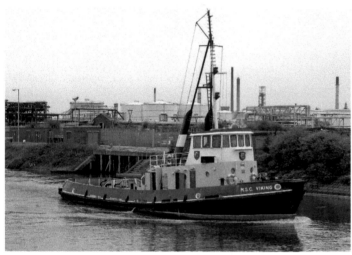

Manchester Ship Canal tug *MSC Viking* (1976/137grt).

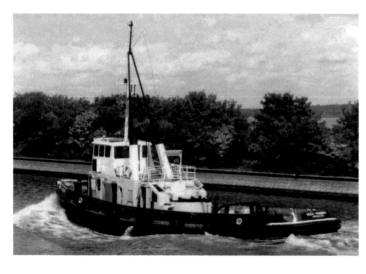

MSC *Viceroy* (1975/137grt) at speed in the Manchester Ship Canal.

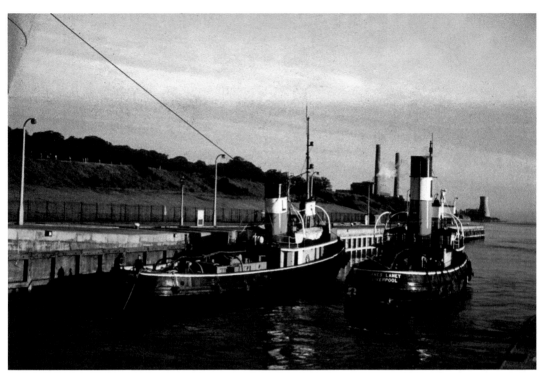

Anita Lamey (1920/172 grt) and *James Lamey* (1968/219 grt) at the entrance to Eastham locks.

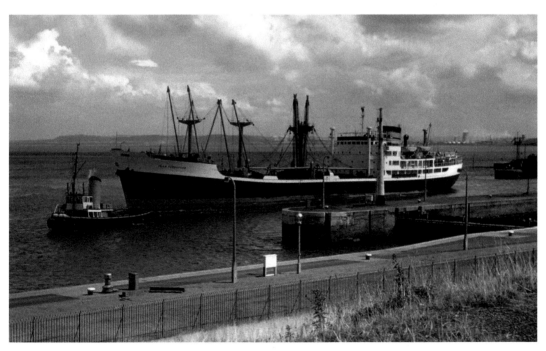

Clan Fergusson (1961/9,242 grt) leaving Eastham. It became *Jalapankhi* in 1965, and was broken up at Bombay in 1983.

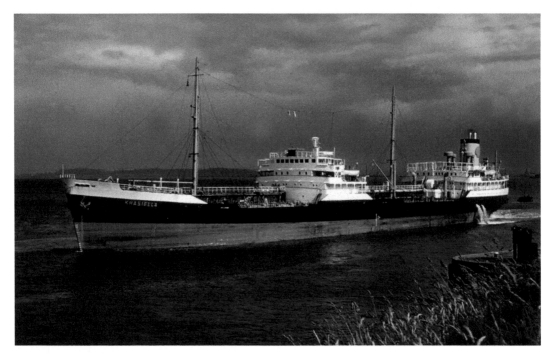

The Shell tanker *Cinulia* (1955/9,094 grt) at the entrance to Eastham. It was broken up in Serang in 1986.

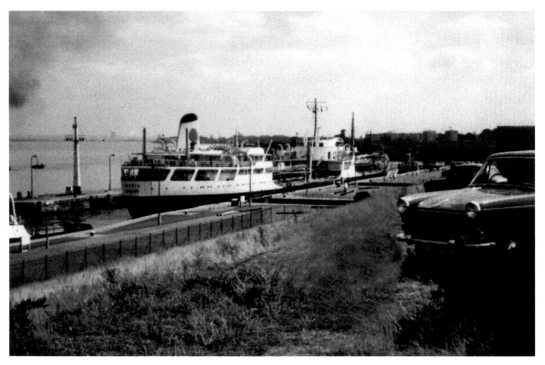

Shell's *Amoria* (1960/12,324 grt) was renamed *Uje* in 1979, and was broken up at Aliaga in 1986.

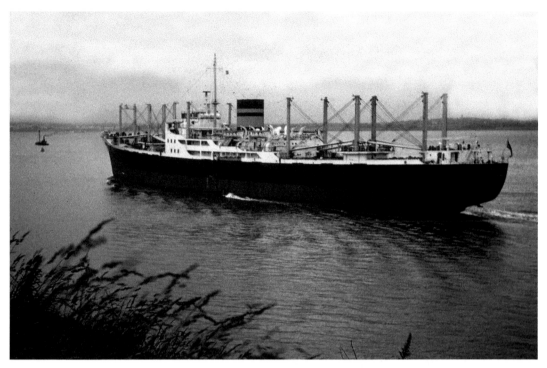

Pacific Envoy (1958/9,439 grt) was renamed *Loch Ryan* in 1967, *Pacific Envoy* in 1970 and *Aegis Strength* in 1971. It was broken up in 1974.

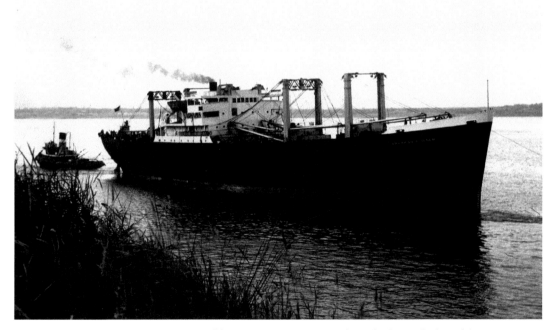

United States Line's *American Builder* (1945/6,214 grt) was launched as *Whirlwind*, becoming *American Builder* in 1948. It was broken up in 1973 at Kaohsiung.

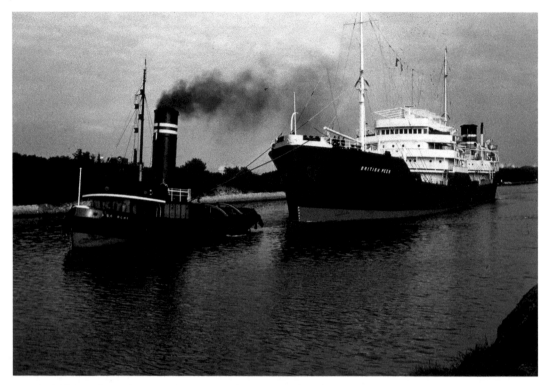

British Peer (1950/8,661 grt). It was broken up at Valencia in 1963.

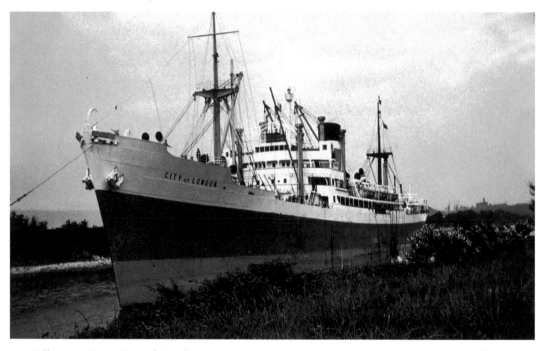

Ellerman Line's *City of London* (1947/8,434 grt) was renamed *Sandra N* in 1966, and was broken up in 1968 at Kaohsiung.

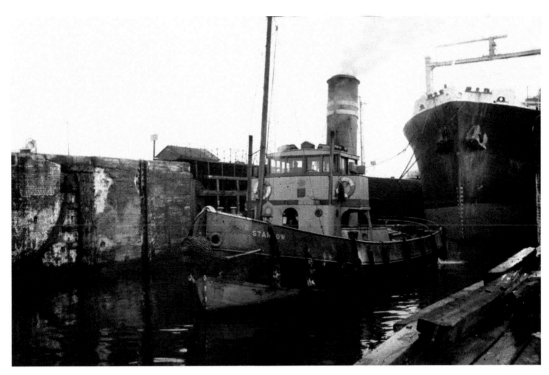

The tug *Stanlow* (1924/100 grt) was launched on 2 May 1924 by W. J. Yarwood & Sons at Northwich.

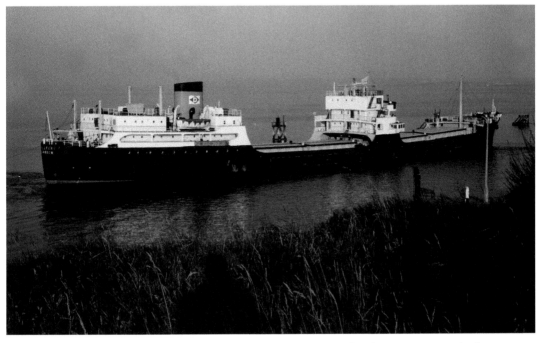

Wellpark (1958/6,859 grt) was built as *Needles*, becoming *Wellpark* in 1960. It was broken up at Faslane in 1973.

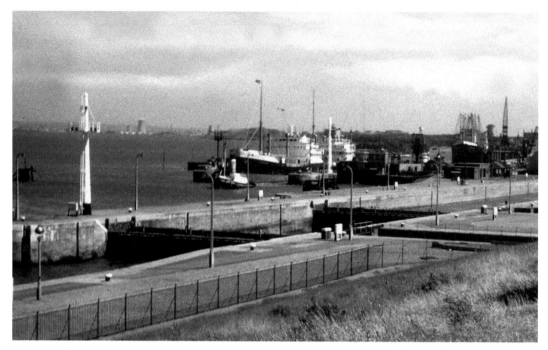

Cinulia (1955/9,094 grt) emerging from Eastham locks. It was broken up in 1986 at Serang.

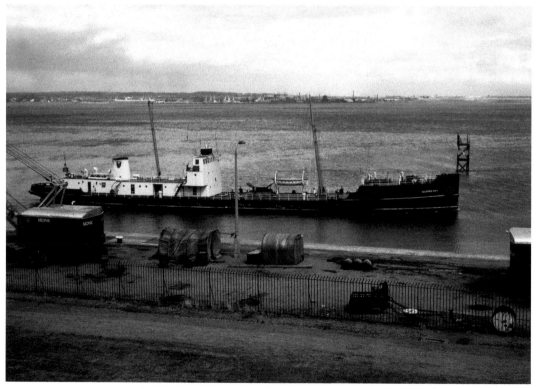

Salford City (1928/1,179 grt) was re-engined in 1963 and broken up at Fleetwood in 1976.

Parkgate, Shotwick, Burton, Neston and Dawpool

Parkgate was a busy port from around 1730 to the end of the century. It had its own Custom House and officers, and local pilots and captains were employed to guide vessels in and out of the port. The estuary of the River Dee at its mouth has a width of about 6 miles, from Hilbre Point in the Wirral to the Point of Air in Flintshire. The main channel ran close to the Wirral shoreline, and places like Shotwick, Burton, Neston, Parkgate and Dawpool became important ports on the Dee. However, in the early part of the fourteenth century the silting up process began to affect ships using these ports. A charter of 1445 covering the prosperity of Chester mentions that great difficulty was experienced in the navigation of any but the smallest vessel as far as Chester. It records that during the reign of Edward I, for some time no merchant ship could approach within 12 miles of Chester. Work started around 1541 on a new quay at Neston but a lack of funds meant that construction came to a halt six years later, and it was not completed until 1576. In 1677. Andrew Yarranton wrote in his book *England's Improvement by Sea and Land*, 'In the month of July, 1674 I was prevailed to survey the River Dee running by the City of Chester into the Irish Sea, and finding the river choked with the sands so that a vessel of 20 tons could not come up to that noble city, and the ships forced to lie at Neston in a very bad harbour.'

There is a consensus of opinion that the silting process has been greatly accelerated by the reclamation operations, and the restriction of the tidal flow in the upper part of the estuary to a narrow artificial channel. The Tidal Harbours Commission of 1845–46 stated that 'the engineering blunders perpetrated have had a disastrous effect on what should have been a great artery of commerce. There is no physical or geographical reason why the Dee should not carry as large a volume of trade as the Mersey'. It is ironic that the works were carried out for the purpose of improving the navigation of the river. The decline in the estuary of the Dee, from a waterway of importance in the early Middle Ages, is in contrast with the rise of the Mersey as a small port in the beginning of the seventeenth century.

Up to the mid-nineteenth century Neston was the centre of local administration. It had a weekly market and fair three times a year, and from the sixteenth century it was the main port on the River Dee, with trade to Ireland. There was a variety of hotels, inns and other accommodation for travellers to use when sailings were delayed due to bad weather. Webb wrote in 1615 that Great Neston was 'the usual place where our passengers into Ireland do so often lie waiting the leisure of the winds, which makes many people better acquainted with this place when they desire to be, though here be wanting no convenient entertainment'. In 'The Town and Port of Great Neston' of 1816, the New British Traveller refers to Birkenhead as 'situated 9 miles N N E of Great Neston'. Around 1550 a quay was built at Neston but changes in the estuary made it unsuitable, being replaced with a stone sea wall and a New Quay about a mile further north at Parkgate.

Following the sale of the New Quay at Neston to Sir Roger Mostyn in 1799, it is thought that the stone blocks were used to build the quay wall at Parkgate. At the beginning of the nineteenth

century Parkgate was a busy port, with accommodation for travellers, coaching stables and it was also a fashionable summer resort with an important fishing industry. Dependant on the weather the voyage to Dublin could take from fourteen hours to three days, or even longer. The journey from North Wales to Liverpool was shortened by the use of small ferries operating from Flint and Bagillt. The composer Handel enjoyed his stay at the George, an inn which stood on the site of the Mostyn House School, and it is claimed that he completed the Messiah while at the premises. However, he had become involved in a dispute between George II and his eldest son, Frederick, Prince of Wales. The prince used his fortune to ruin Handel, and in 1737 Handel was made bankrupt. He responded by isolating himself and on his return to society he attempted to promote his composition. After little success in London, he decided to go to Dublin and came to Parkgate to board a sailing ship for the journey across the Irish Sea. He arrived in Chester in 1741 after being delayed at Parkgate for several days because of the weather, and persuaded the cathedral organist to recruit a choir who helped him research and finalise the score for the Messiah. On arrival at Dublin the first performance of Messiah took place at the New Music Hall in Fishamble Street on 13 April 1742 where it received positive reviews. The work was performed at Covent Garden in London on 23 March the following year, and the audience, including King George II, rose to their feet during the 'Hallelujah' chorus. John Wesley, the evangelist, crossed the Irish Sea more than forty times, usually sailing from Parkgate. On one visit he preached at the new chapel at Neston on 1 April 1762, while waiting for the weather in the Irish Sea to improve. On 11 July 1787 he was on board the Parkgate vessel *Prince of Wales* when it grounded off Holyhead. Wesley led prayers on deck and the vessel refloated with the tide and proceeded to Parkgate.

The *Ancient Briton*, a steam packet, was introduced on the Parkgate-Bagillt service in June 1817 and new piers were built at Parkgate and the other terminals. A coach conveyed passengers for Liverpool to Tranmere, where they continued on their journey on the *Regulator*, another steam-driven vessel. A direct coach operated three times a week between Neston and London despite the roads being in a bad state of repair. Following the opening of the Birkenhead–Chester railway in 1840 the passenger numbers on the River Dee ferries declined, eventually making them become uneconomic to operate. Changes in the position of the channel through the estuary, and the development of industry and commerce on the Mersey saw Parkgate decline as a port.

Mostyn House School was originally opened in Tarvin, and moved to Parkgate in 1865. It closed in 2010 and was run by the Grenfell family as a boys' boarding school. The chapel was designed by Frederick Fraser and Warburton and the headmaster A. G. Grenfell. On closure of the school in 2010 the bells were transported to Charterhouse School. The 6th Duke of Westminster's children attended Mostyn House School including Hugh Grosvenor, the 7th Duke of Westminster.

During the early years of the twentieth century Parkgate was a busy fishing port with around thirty fishermen working from the village. At high tide in the 1930s there was a depth of five fathoms under a boat's keel and cockles and mussels were unloaded onto the slipways, and transported to Parkgate station where they were taken by rail to Liverpool and Manchester and other destinations in the United Kingdom. It is thought that James and Christopher Peters were the last fishermen family to operate from the port. There were also six daughters in the family who also assisted in the business, shelling the shrimps and maintaining the nets. The Parkgate Fishermen's Regatta took place every summer prior to the First World War and competitors came from Heswall, Thurstaston, Mostyn, Connah's Quay and other towns and villages on the River Dee. Races were held between Parkgate and across the estuary to Mostyn, returning back to Parkgate. The final regatta took place in 1914.

Cows graze on the overgrown beach at Parkgate.

The Watch House on the main road leading to Parkgate.

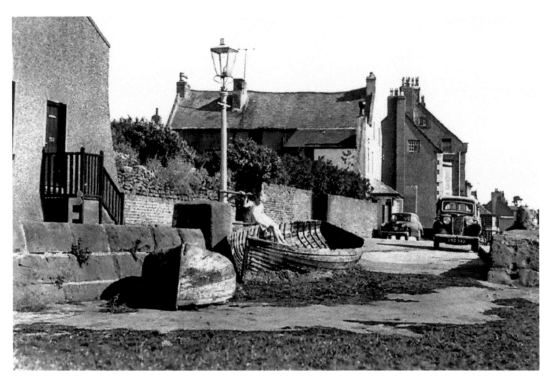

Above and below: The promenade at Parkgate at low water.

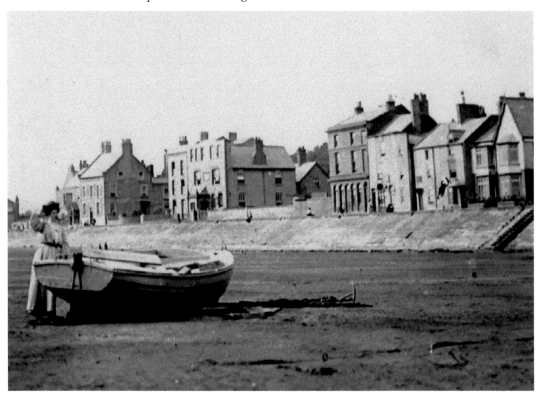

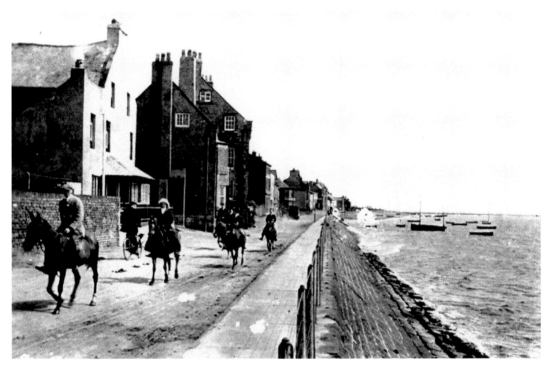

Riders exercise their horses on the promenade at Parkgate.

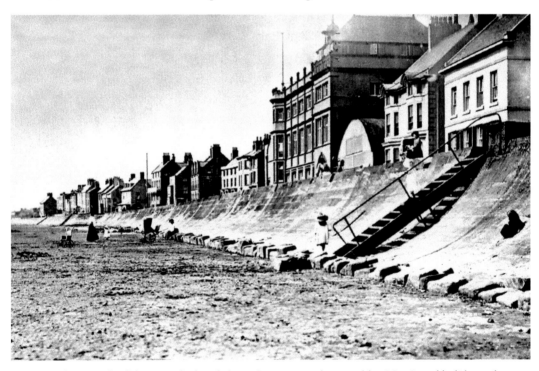

Wooden steps lead down to the beach from the promenade to enable visitor's and holidaymakers to walk along the shore.

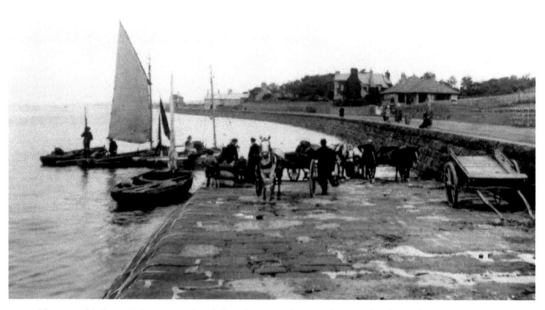

Above and below: Fishermen unload their boats and carry their catch of cockles and mussels on to carts parked on the slipway.

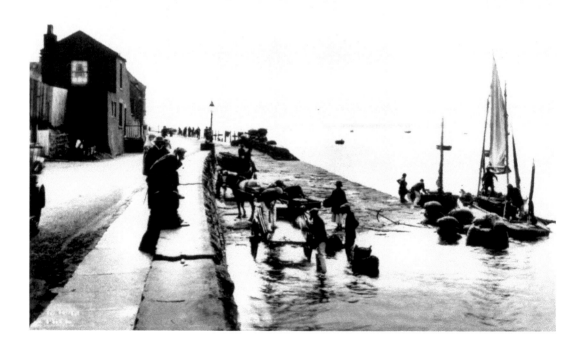

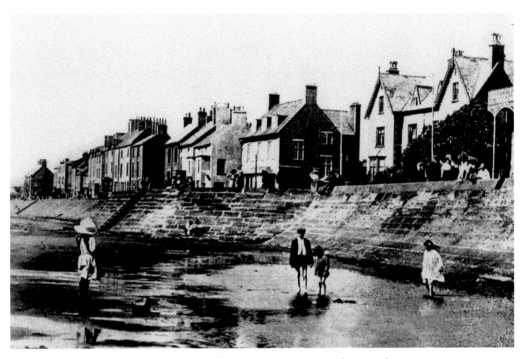

Families enjoy a day on the beach when Parkgate was a popular seaside resort.

The Port of Mostyn and Shotton

The Port of Mostyn, on the River Dee, is one of the oldest ports in the country and specialises in the assembly of wind turbines for the North Hoyle, Burbo Bank, Rhyl Flats, Gwynt y Môr, Robin Rigg and Walney windfarms. The port comprises of Riverside Quay and a roll on/roll off terminal with direct access to the national road and rail network. Shotton on the Dee Marshes was developed by John Summers & Sons, who owned a fleet of ships that were used to take steel from their wharf to Liverpool for shipment to customers around the world.

Mostyn was mentioned in the Domesday Book of 1086, and Henry Bolingbroke landed there in 1399 prior to his combat with Richard II at Flint Castle. In the nineteenth century coal was mined at Mostyn and iron production took place. Mostyn was an ideal location for the enterprise with the combination of a colliery, ironworks and the docks. Around 1,900 people were employed at one time. The coal became exhausted and the ironworks closed in 1965. A railway station was opened at Mostyn in 1848 on the Chester to Holyhead line, and this survived until it was closed in 1966.

In the past the port has handled cargoes including steel, coal, timber, woodpulp, animal feedstuffs and fertilisers. Wings manufactured for the Airbus A380 at Broughton were brought down the River Dee on special vessels and shipped from Mostyn on the Ville de Bordeaux until February 2020, when production ended at Airbus because of a lack of orders for the A380. The Port of Mostyn Limited is a privately owned and operated port. It is a Statutory Harbour Authority and also the Statutory Pilotage Authority for navigation in the estuary. It is the last working survivor from the number of small ports along the southern shore of the River Dee. In 2001 the Welsh Assembly invested £17 million, which allowed the port to gain a contract from P&O Ferries to operate passenger and vehicle ferries to Dublin. Services were transferred from Liverpool and the new route cut one and a half hours off crossing times to and from Dublin. However, the service was closed in 2004, mainly because of dredging problems in the River Dee.

There are plans for a new tidal lagoon to be built near the port. Mostyn SeaPower Limited want to build a 6.7-kilometre-long lagoon, and claim that it could provide low carbon electricity to power 82,000 homes. They say the Dee Estuary is an ideal location because it has one of the highest tidal movements in the United Kingdom, which can be as much as 10.2 metres during spring tides. There is also natural deep water for the installation of the turbines. The lagoon wall is planned to be 2 metres above sea level, which will also provide flood protection for the low-lying land along the coast. It will have two sets of turbine houses with three sluice gates to control the volume of water over the tidal cycle, along with lock gates allowing small vessels in and out of the sheltered lagoon. There will be eight 16 megawatt turbines which will generate 298 gigawatt hours of electricity annually from the lagoon, which will enclose an area of 12.2 square kilometres and will have a design life of more than 100 years.

It is envisaged that the construction time for the lagoon wall, turbine housings and sluices will take approximately four years. Manufacturing of the turbines will take two years to complete and will be carried out in conjunction with the wall construction. The turbines will be assembled at the port and will be installed simultaneously with the lagoon wall. As each turbine is tested

and commissioned it will be connected to the grid. The first power is expected to be delivered to Connah's Quay in mid-2027, and the project completed by the end of that year. It is thought that around 300 jobs will be created at the port and further employment will be secured in local companies.

John Summers & Sons owned a fleet of ships that were used to carry steel from the wharf at Shotton to Liverpool Docks where it was transferred to ocean-going vessels. Known locally as the 'Beetle Fleet', in 1918 it consisted of nineteen ships. Summers had been established at Stalybridge and had commissioned the building of the Hawarden Bridge at Shotton. In 1894 the company was looking for land upon which to build a new factory for sheet rolling mills. Henry Summers visited Connah's Quay and asked a local boatman to take him up the River Dee. The boatman took him in the direction of Chester. Summers decided that the site was ideal as there was a newly constructed railway connection to the town. Summers bought 40 acres at a price of 2s 6d (12 ½p) per acre. A further 50 acres was later acquired and the railway sidings were also purchased, connecting to the MS&L Railway.

The *Buffalo* and *Rio Formosa* were the first two steamers that were acquired by the company in 1897. The *Maurita* was sold to a firm in Lancaster in 1935 and during the Second Word War it collided with a mine in the Dee Estuary, and all of the crew were lost. Several of the fleet were requisitioned by the Admiralty during the war and were used as tankers. One was operated by the Air Force as a buoy boat, and two others were transferred to the Navy. Stalybridge and Hawarden Bridge were fitted with guns at Liverpool. Hawarden Bridge was the first ship to enter Dunkirk Harbour after the liberation of the town. It was sold to a company in Barbados in 1967, and in 1978 was found abandoned and adrift. Its engines were flooded and there was no sign of any crew or officers. It was later towed to Miami.

Paulina B (1975/926 grt) was launched as *Paulina Brinkman*, becoming *Paulina B* in 1987 and *Pauline* in 2002.

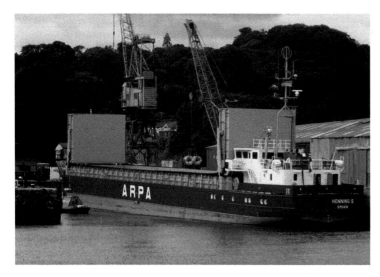

Henning S (1989/1,307 grt) became RMS *Rahm* in 2005, RMS *Vindava* in 2007 and *Clarity* in 2013.

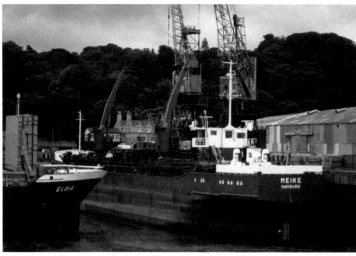

Meike (1983/999 grt) was launched as *Frauke*, becoming *Faun* in 1988, *Meike* in 1989, *Montania* in 1992 and *Sierksdorf* in 1996. It suffered an explosion on 2 December 2002 at Aalborg and sank. It was later broken up at Esbjerg the following year.

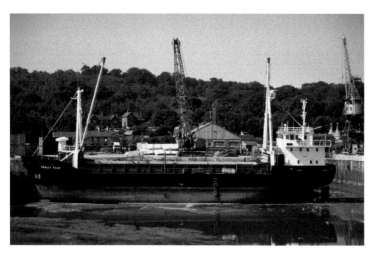

Danica Four (1984/997 grt) was renamed *Isla Maillen* in 2012.

Anne Boye
(1985/1,501 grt)
became *Asia* in 2006.

Skyron (1970/999 grt)
was launched as *Julia*,
becoming *Sykron* in
1990 and was broken
up at Aliaga in 2012.

Celtic Voyager
(1975/924 grt) was
launched as *Alannah
Weston* and was
constructed in three
parts and completed at
Harlingen, becoming
Celtic Voyager in 1984.

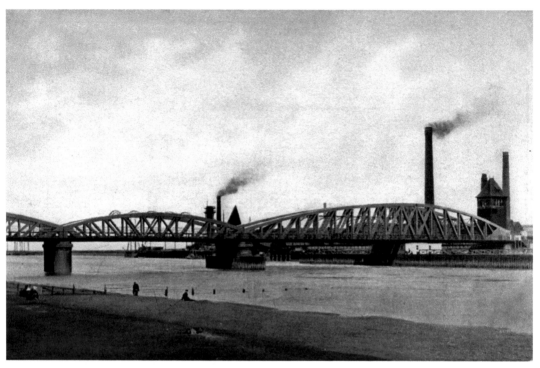

Hawarden Bridge at Shotton.

Staley Bridge (1940/297 grt).

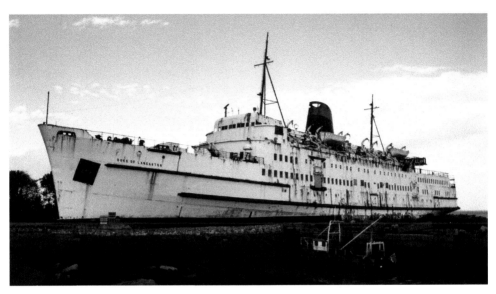

Above and below: Duke of Lancaster (1956/4,797 grt). It was launched on 14 December 1955 for the Heysham–Belfast service. In 1966 it operated three- and four-day cruises and in 1969 it was converted to a stern loading car ferry. On 6 April 1975 the Heysham–Belfast service discontinued and it operated on the Fishguard–Rosslare service and later Holyhead–Dun Laoghaire in 1975. Its final sailing, Holyhead–Dun Laoghaire, took place on 9 November 1978, and it was laid up at Holyhead. It was transferred to Sealink UK Limited on 1 January 1979, laid up at Barrow and was sold to Empirewise Limited. It was towed to Mostyn in August 1979 and renamed *Duke of Llanerch-y-Mor*. In May 1980 it opened as a leisure facility without planning permission. The owners have been in dispute with the local council ever since then, but the ship has remained closed. The coin-operated arcade machines were sold in 2012, and there are now plans to transform the hull into the largest open-air gallery in the United Kingdom.

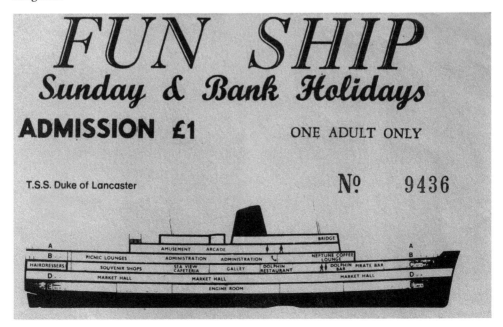

J. Crichton & Company, Shipbuilders at Saltney and Connah's Quay

It is recorded that during the nineteenth and twentieth centuries there were up to fourteen shipbuilding yards on the banks of the River Dee, from Chester to the Point of Air. Charles Crichton served an engineering apprenticeship before going to sea, becoming a Chief Engineer for the Hall Line. In 1879 he was a partner in the Liverpool ship repairers, J. Allan & Company, which later became C&H Crichton Limited. His son James followed his father by qualifying in Engineering and Applied Science at the Victoria University, Manchester. He then served his apprenticeship at Glasgow with the marine engineering company David Rowan. On his return to Liverpool, he began work at his father's ship repair firm in Bootle. The company were advertised as specialising in ship repairs, engineering, boilermakers, coppersmiths and brass founders. They were the early pioneers of electric welding and acquired portable machines that were used around the docks at the Port of Liverpool when required.

When Charles died in 1912, James decided to diversify the business into shipbuilding and opened a yard on the River Dee at Saltney. In 1913 there were only two other shipbuilding yards in existence on the River Dee, one at Queensferry and the other at Chester Low Basin. The company opened another yard at Connah's Quay in 1918 and all types of vessels such as tugs, barges, passenger/cargo ships, oil tankers, lightships, coasters and yachts were constructed at both of these yards. The yard at Connah's Quay closed in 1932 and Saltney three years later after the death of Charles Crichton in March 1932. The two yards were acquired by National Shipbuilders Security Limited in 1935, and they were then dismantled.

The following tugs were built by J. Crichton & Company, at Saltney.

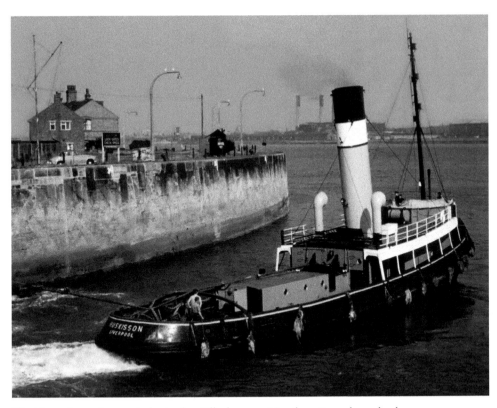

Huskisson (1934/201 grt). Arrived at Silloth on 20 March 1965 and was broken up.

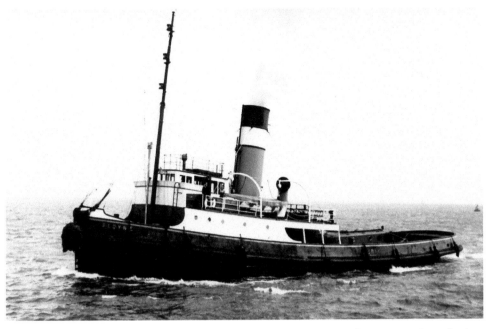

Sloyne (1928/300 grt) was sold to C Brand at Belfast in 1966, renamed *Lavinia*, and was broken up at Passage West, Cork, in May 1970.

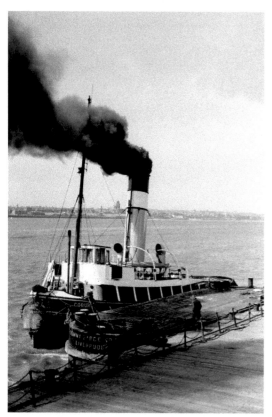

Left: *Coburg* (1934/201 grt) sank in Gladstone Dock on 10 August 1946 following a collision with the *Empire McKendrick*. It was raised on 15 August 1946 and sold to Wards. It was towed to Preston by J. H. Lamey, where it arrived on 1 February 1965 and was broken up.

Below: *Salthouse* (1935/192 grt). It was also broken up at Preston in 1965.

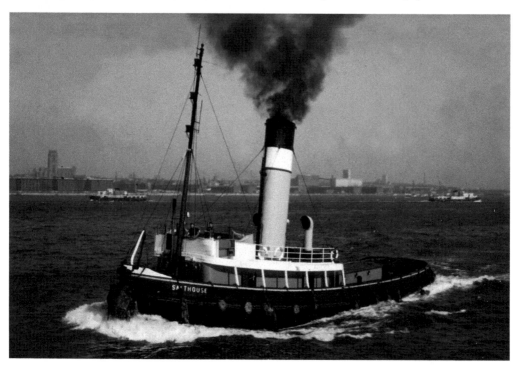